IMAGES
of America

ABBEVILLE
COUNTY

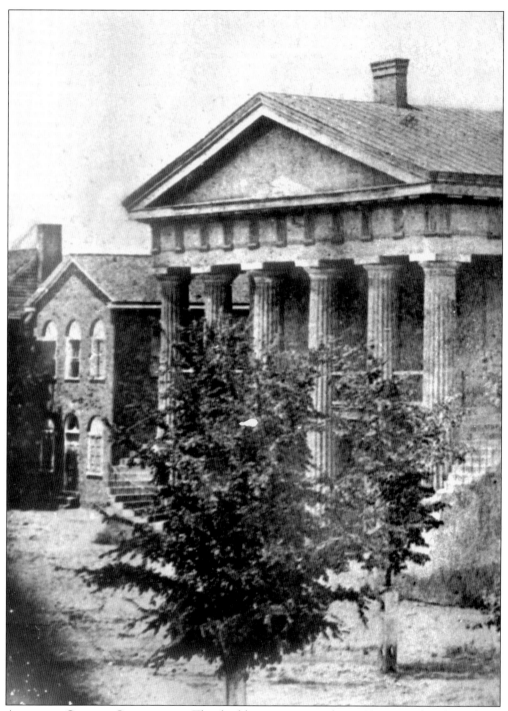

ABBEVILLE COUNTY COURTHOUSE. This building, constructed in 1829, is said to have been Abbeville's first "real courthouse," even though it was actually the third courthouse site. The stone structure with winding side steps was demolished because of faulty construction on the back wall and was later replaced by the courthouse that preceded the current courthouse. The 1829 structure was designed by Robert Mills, who was then living in Abbeville.

IMAGES
of America

ABBEVILLE
COUNTY

Abbeville County Historical Society

ARCADIA
PUBLISHING

Published by Arcadia Publishing
Charleston SC, Chicago IL, Portsmouth NH, San Francisco CA

Printed in the United States of America

Library of Congress Catalog Card Number: 2004105600

For all general information contact Arcadia Publishing at:
Telephone 843-853-2070
Fax 843-853-0044
E-mail sales@arcadiapublishing.com
For customer service and orders:
Toll-Free 1-888-313-2665

Visit us on the Internet at www.arcadiapublishing.com

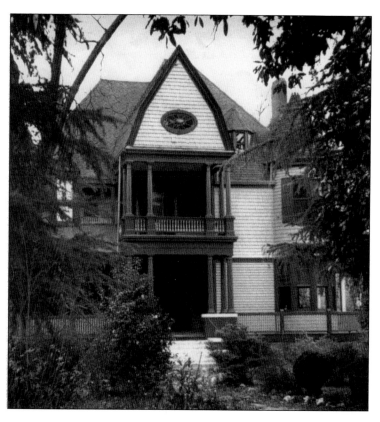

BUNDY-BARKSDALE-McGOWAN HOME AND HEADQUARTERS FOR THE ABBEVILLE COUNTY HISTORICAL SOCIETY. After Confederate general Samuel McGowan's spacious Gothic Revival home, which was built by the late Col. James M. Perrin, burned in 1887, he built this house in 1888. The architect, G.L. Norman of Atlanta, utilized the Queen Anne style for the home. It was subsequently lived in by Gen. William E. Barksdale's family and given to the society by his nephew, J.D. Bundy. It also houses the Jane Greene Center for the Arts.

CONTENTS

ACKNOWLEDGMENTS

A thank you to the Abbeville County Historical Society for having put this book together! It is the first known sizable collection of old Abbeville County photographs to have been published in book format. Fortunately, we were able to collect more photographs than we could possibly use in this book, and these are now preserved in our society's archives. Nevertheless, it is unfortunate that we could not publish all of the photos. Some were faded or damaged, some had no associated information, some were not old enough for this project, and others were never brought forth. Additionally, we were not able to use every photo as we tried to give a good representation of each town and related small communities in our county. However, let's remember this is also representative of what was shared with us.

Acknowledgments to some of our early known photographers would make a nice starting point. How very fortunate we are that Mr. Malcolm Val Lourie Lomax was making glass negatives in the late 1800s in Abbeville and that he did some of ordinary scenes when photography was still new and a somewhat expensive novelty for a rural area. He was among those who preserved our early photo history by catching everyday life.

Next, we salute the late Mr. Franklin S. Hays Sr., for he purchased and saved many of Mr. Lomax's glass negatives. In the late 1950s, Mr. Hays was a familiar site on the sidewalk near the entrance of his upstairs studio on the Abbeville square; a marquee of portable photos was always seen near that entrance. He was among those who added to the preservation of our pictorial history with his daily shots. Thanks to his family who shared!

The genesis of this little book came about from the persistence of the historical society vice president, Miss Alicia Joy Harvey. From her constant requests, the ACHS Board created a committee headed by her to bring this project to fruition. A resounding thank you, Miss Harvey! Other hardworking committee members included Ms. Marilyn Reid, who found photos and made calls; Ms. Harriett Simpson (historical society secretary), who spent hours preparing our captions; Dr. John Alexander, who provided technology support and scanned the photographs; our president, Mr. Bob Speer, who cheered us on and collected photos; our Due West photo "scout" Mr. Millen Ellis; and Mr. Bill Rogers (past president) for his dedication, photos, and excellent knowledge of Abbeville history. Thanks to all of them for giving up many, many hours to place our history, and this book, above themselves.

Last but equally important was the support from all of our kind citizens who searched through drawers and closets to find long forgotten photos and then shared them. We also thank our Abbeville Chamber of Commerce and the Abbeville County Visitors Council for their resources and contribution.

In viewing these photos, one quickly realizes that we have lost many of our wonderful old buildings. Some were lost to fire, others to demolition or neglect. Hopefully this book will heighten interest in our historical structures that remain. In closing, we apologize in advance for any and all errors or oversights.

INTRODUCTION

The towns of Abbeville County, South Carolina, began in the late 1700s. The county seat of Abbeville has a long-standing reputation of being a little historical jewel of the Upcountry, but the history is equally rich in the county's other towns and small neighboring communities. The whole area is somewhat removed from the maddening crowds of the world and retains a charm of its own. It's both a good place to visit and a good place to live.

A primary goal of the Abbeville County Historical Society, in doing this book, was to share and preserve our history in as many old photos as allowed by the publisher. In addition, we have provided appropriate verbiage to the extent it was found. Much of the information pertaining to rural areas was unpublished history, and that was an additional important goal of the historical society's committee.

The citizens of our county and of their respective towns, their ancestors, and the good deeds they have done represent the real history that is of utmost importance. After all, it is the men, women, and children who make a place. Thus, we have recognized this with their portraits and photographs, street scenes, and venues. Some have accomplished simple deeds and have done them well; this allowed others the support that they needed to go on to do greater things. We are thus thankful for our ordinary men and women and have showcased them along with our notable citizens.

These notables comprise those who gained statewide, national, and international recognition. Among them one finds a U.S. vice president, an ambassador to Siam, a South Carolina governor, a South Carolina Supreme Court associate justice, a notable architect, senators, and military leaders, including lieutenants, majors, colonels, and generals.

Along with our earlier citizens, we have showcased the buildings they constructed; it is the brick, mortar, and wood that we have called home over the ages. They are the buildings in which our ancestors worshiped, lived, became educated, worked, conducted business, and shopped. Many of these edifices we still use today and treasure for their unique and intrinsic value. The historical society's book committee wanted our present and future generations to see a glimpse of our rich and often robust past. This is "Our Abbeville County," a place we love, a place we live in. It's a place we call home, now preserved in a little book of old photos.

In seeing the many wonderful old buildings in this book that we have lost to time, it brings to mind Deuteronomy 19:14: "Thou shalt not remove thy neighbor's landmark, which they of old time have set in thine inheritance, which thou shalt inherit in the land that the Lord thy God giveth thee to possess it."

It is also hoped that this glimpse into our history will instill pride in our citizens and inspire them to continue to record our history, protect our remaining old buildings, and understand the merits of historic preservation. For our visitors, may this souvenir bring pleasant memories and also increase your interest in historic preservation. Thank you for purchasing this book!

In summation, one could quote another Biblical saying that comes to mind. "Of making many books there is no end" (Ecclesiastes 12:12). One can rest assured that this was applied to the work and the efforts that went into this historical photography documentation. It is hard to call a closure to a project of this magnitude, but the publisher helped with a mandated deadline. When late one night we at last finished, it was "La Bella Notte"!

One

GEN. SAMUEL MCGOWAN AND HIS LEGACY

This distinguished and gallant lawyer, legislator, soldier, and judge made his home in Abbeville before and after the Civil War. His last home is now the headquarters of the Abbeville County Historical Society.

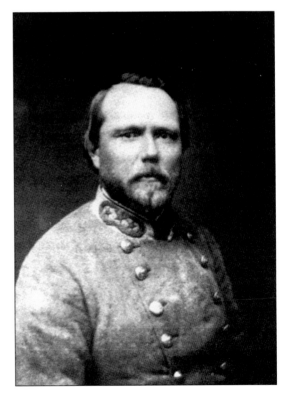

GENERAL MCGOWAN OF THE CONFEDERATE STATES OF AMERICA. General McGowan displayed bravery in numerous battles in Virginia. He was promoted to brigadier general on January 17, 1863, and took command of Maxcy Gregg's brigade after Gregg's death at Fredericksburg. After the war, McGowan returned to Abbeville and became a member of the legislature and an associate justice of the South Carolina Supreme Court. He died at his home on North Main Street and is buried in Long Cane Cemetery.

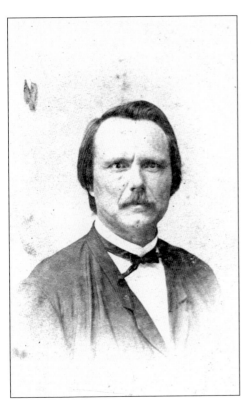

SAMUEL McGOWAN. General McGowan is shown here as a young man in a photograph that was taken at the R. Wearn Studio in Columbia, South Carolina. A noted and active Abbeville citizen, he was a veteran of the Mexican War, a general in the Civil War, an Abbeville attorney, and an associate justice of the state supreme court. The Abbeville County Historical Society owns the home he built in 1888.

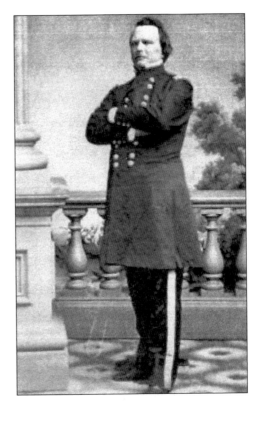

SAMUEL McGOWAN. General McGowan appears to be in a uniform from the Mexican War period. In 1846, he entered the Palmetto Regiment as a private, rose to the rank of captain, and for a time served as a volunteer aide-de-camp to Brig. Gen. John A. Quitman, whose division stormed the Beden Gate. McGowan was complimented for gallantry in action near Mexico City.

MASS MEETING. Shown here is a copy of the notice of the mass meeting in November of 1860. The meeting was held in order to nominate delegates to the convention that voted to secede from the union. Samuel McGowan spoke at the meeting in opposition to secession, even though he later became one of the most distinguished generals of the Confederate Army.

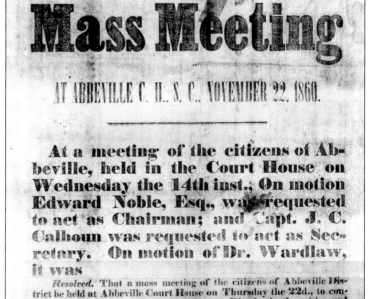

Mass Meeting

AT ABBEVILLE C. H., S. C., NOVEMBER 22, 1860.

At a meeting of the citizens of Abbeville, held in the Court House on Wednesday the 14th inst., On motion Edward Noble, Esq., was requested to act as Chairman; and Capt. J. C. Calhoun was requested to act as Secretary. On motion of Dr. Wardlaw, it was

Resolved, That a mass meeting of the citizens of Abbeville District be held at Abbeville Court House on Thursday the 22d., to consult as to the course to be pursued by our District in the crisis, and that a Committee of twenty-one be appointed to make all necessary arrangements.

Distinguished Speakers have been invited to address the people on that day---Hon. Robt. Toombs, of Georgia; Hon. James Chesnut, Hon. James H. Hammond, Hon. M. L. Bonham, Hon. A. G. Mograth, Hon. W. F. Colcock, James Conner, Esq., and others.

SECESSION HILL POSTCARD. This old postcard from McMurray's Drug Store reads, "First Secession meeting held beneath these trees [on the right], November 22, 1860."

11

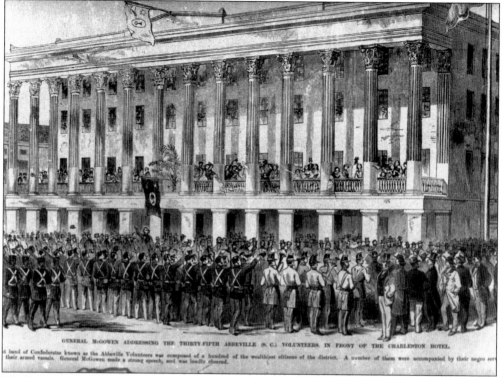

GENERAL McGOWEN ADDRESSING THE THIRTY-FIFTH ABBEVILLE (S. C.) VOLUNTEERS, IN FRONT OF THE CHARLESTON HOTEL.

A band of Confederates known as the Abbeville Volunteers was composed of a hundred of the wealthiest citizens of the district. A number of them were accompanied by their negro servants. General McGowen made a strong speech, and was loudly cheered.

McGOWAN'S REVIEW IN HARPER'S WEEKLY. This renowned drawing depicts Gen. Samuel McGowan reviewing his troops in front of the Charleston Hotel. An original print of the *Harper's Weekly* drawing hangs in the Abbeville County Historical Society.

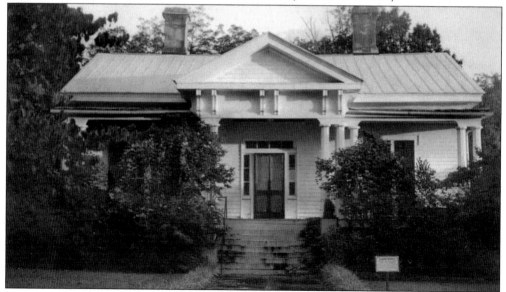

McGOWAN HOUSE. Shown here is Gen. Samuel McGowan's antebellum house on Magazine Street, which was built in the 1850s in a raised-cottage, Gothic Revival style. General McGowan and his family lived here prior to the Civil War. This house was moved *c.* 1919 from further back on the property.

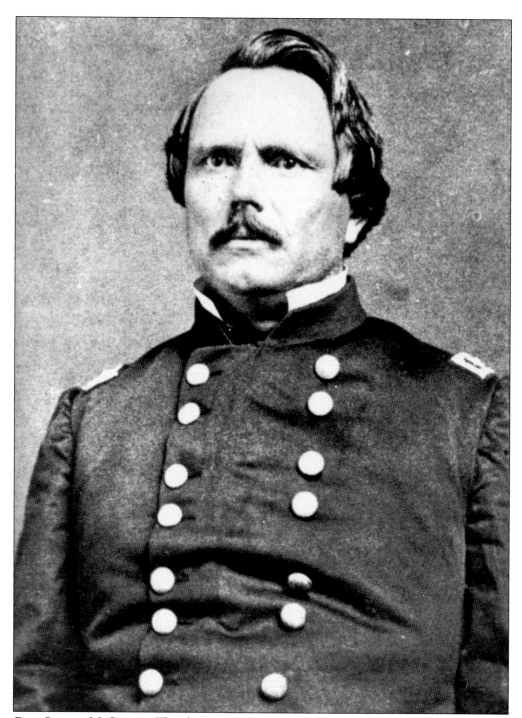

GEN. SAMUEL MCGOWAN. This distinguished general served with the Confederacy from 1861 to 1865 and was a participant in many major battles, including the First and Second Battles at Manassas, as well as the Battles of Fredericksburg and Chancellorsville. It has been said that his combat record was unexcelled by any other brigade commander. He was fearless in battle and was wounded four times. General McGowan surrendered with the army at Appomattox.

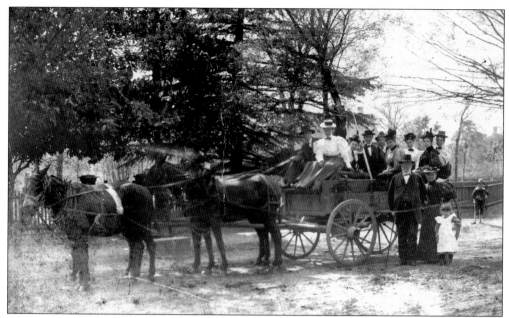

McGowan Family. Gen. Samuel McGowan is pictured at the far right with the cane. In the driver's seat are his son, William Campbell McGowan, and William's sister, Lucia McGowan. William McGowan's wife, Clelia, and daughter, Olive, are standing with General McGowan. The others are unidentified. Dated April 10, 1896, this image is the last known photograph of General McGowan and was made in front of the general's home on North Main Street.

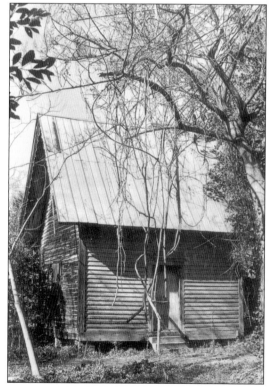

Slave Cabin. Depicted here is one of the servant cabins behind the Bundy-Barksdale-McGowan House on North Main Street. This structure was built in the early 1850s in the Gothic Revival style with sawn bargeboard and plaster walls. It is part of the property originally built by Col. James Perrin of the Confederacy to go with his very handsome and spacious home.

WILLIAM CAMPBELL McGOWAN. This portrait of Gen. Samuel McGowan's son, William, hangs in the Bundy-Barksdale-McGowan House, which is now the headquarters of the Abbeville County Historical Society. William oversaw the building of the Bundy-Barksdale-McGowan House in 1888. A lawyer and popular citizen in Abbeville, he also sang in the Trinity Episcopal Church choir. William McGowan died in his early 40s of pneumonia.

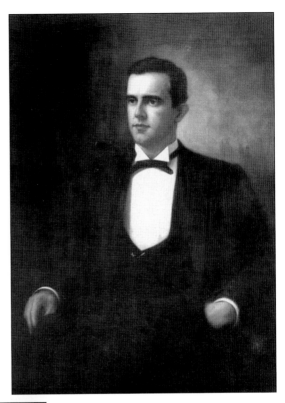

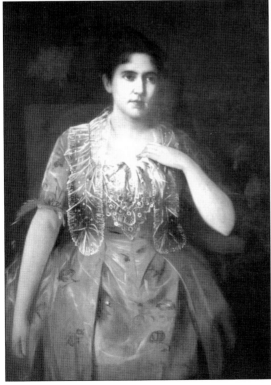

WILLIAM McGOWAN'S WIFE. Clelia Peronneau Mathewes McGowan was the wife of William Campbell McGowan. In Abbeville, she lived in Gen. Samuel McGowan's home. Clelia later moved to Charleston, where she became the first woman elected to the Charleston City Council in 1923. She was also president of the South Carolina United Daughters of the Confederacy from 1897 to 1899. Her portrait now hangs in Charleston's city hall.

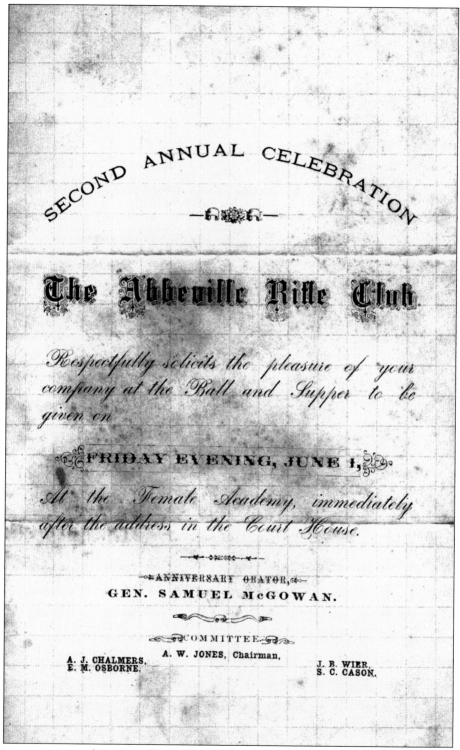

SECOND ANNUAL CELEBRATION

The Abbeville Rifle Club

Respectfully solicits the pleasure of your company at the Ball and Supper to be given on

FRIDAY EVENING, JUNE 1,

At the Female Academy, immediately after the address in the Court House.

ANNIVERSARY ORATOR,
GEN. SAMUEL McGOWAN.

COMMITTEE
A. W. JONES, Chairman,

A. J. CHALMERS,
E. M. OSBORNE.

J. B. WIER,
S. C. CASON.

INVITATION TO THE ABBEVILLE RIFLE CLUB'S SECOND ANNUAL CELEBRATION. Gen. Samuel McGowan was the guest speaker at the rifle club's celebration.

Two

JOHN C. CALHOUN AND SECESSION

John C. Calhoun, the most famous of Abbeville's native sons, was born less than a dozen miles from the village. He later began his law practice in Abbeville and is famously regarded as one of the greatest senators in American history.

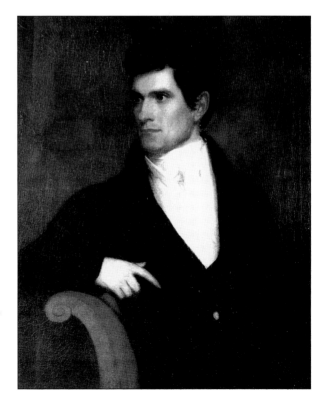

PORTRAIT OF JOHN C. CALHOUN AS A YOUNG MAN. This noted statesman was born and raised in the Abbeville District. He became the secretary of war under President James Monroe, as well as the vice president of the United States to both John Quincy Adams and Andrew Jackson. According to a July 10, 1889 newspaper article from *The Press and Banner*, his first law office was in one room of a house on the Abbeville square known as the "Red House."

AERIAL VIEW OF MILLWOOD PLANTATION. The plantation of James Edward Calhoun, the cousin and brother-in-law of John C. Calhoun, contained 3,000 acres of cultivated land and 9,000 acres of uncultivated land at the time of his death on October 31, 1889. He was 91 years old.

MILLWOOD PLANTATION. This image depicts a view of the main house in the late 1800s. The 12,000-acre estate was owned by James Edward Calhoun. It is now under the waters created by the Richard B. Russell Dam in Calhoun Falls. James Edward Calhoun was born July 4, 1798. He became known as the "Hermit of Millwood" after his wife, Maria Simkins, died in 1844.

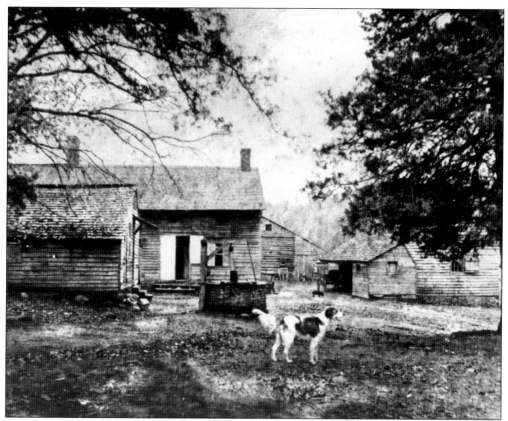

MILLWOOD PLANTATION. This plantation is the ancestral home of the Calhoun family.

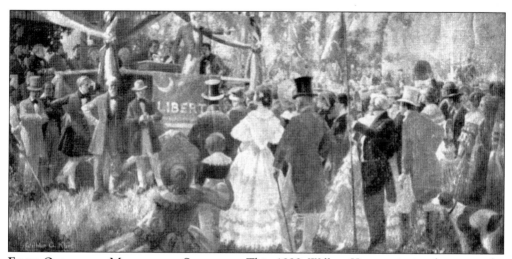

FIRST ORGANIZED MEETING OF SECESSION. This 1922 Wilbur Kurtz painting hangs in the Abbeville Visitors Center. It represents the first organized mass meeting for secession held on November 22, 1860. Gen. Samuel McGowan was also a speaker at the meeting.

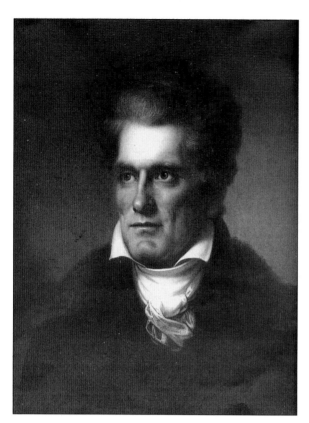

JOHN C. CALHOUN. The most distinguished and brilliant of Abbeville's native sons devoted much of his life to the service of his state and his nation. He represented South Carolina in the United States Senate and served in this capacity until his death in Washington, D.C., in 1850. He is buried in the graveyard of St. Phillip's Episcopal Church in Charleston.

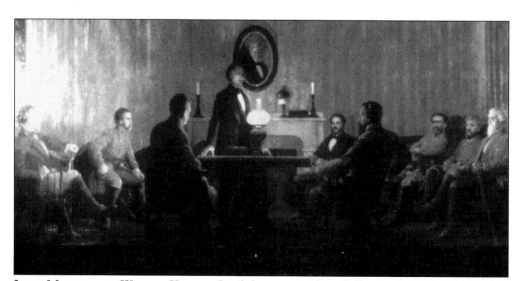

LAST MEETING BY WILBUR KURTZ. Confederate president Jefferson Davis holds his last Confederate War Council meeting with his 12 generals at the Burt-Stark Mansion on May 2, 1865.

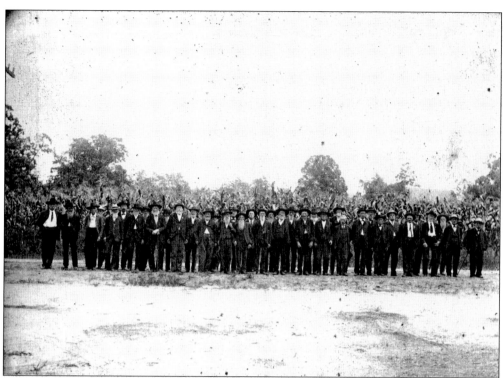

CIVIL WAR REUNION. In 1905, a Civil War reunion was held in Honea Path, South Carolina. The only identified person in this picture is the individual on the extreme right, Col. J. Townes Robertson, who served in Orr's Regiment of Rifles in Gen. McGowan's brigade. At the reunion, Colonel Robertson had a stroke. His horse, Charley, brought him home, but he died shortly thereafter. He was the grandfather of May Hutchinson. (Courtesy of May Hutchinson.)

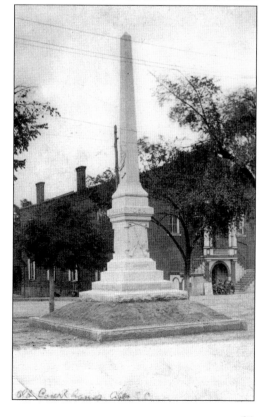

CONFEDERATE MONUMENT AND COURTHOUSE. This picture from the early 1900s shows the Confederate Monument with the previous courthouse in the background. The image was probably made in 1906 or 1907 since the monument was erected in 1906, and the current courthouse was not built until 1908.

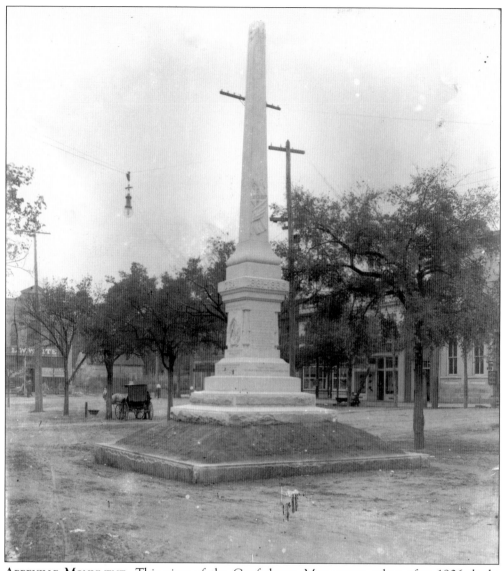

ABBEVILLE MONUMENT. This view of the Confederate Monument, taken after 1906, looks toward the White building, which is now Edith's.

Three

AROUND THE ABBEVILLE SQUARE

The courthouse town of Abbeville was built by the Scots-Irish in 1785. It was named by Dr. John de la Howe for his hometown in France. Abbeville is often referred to as the "Birthplace and Deathbed of the Confederacy." Patrick Calhoun, the father of John C. Calhoun, was one of the settlers who established a frontier settlement here in 1758. The site for Abbeville was chosen on land once owned by Gen. Andrew Pickens of the American Revolution. General Pickens also gave the village a spring for drinking water.

MARSHALL HOUSE. The Marshall House, shown in 1862, was built in 1853 and destroyed by fire in 1872. It stood at the northeast corner of the square facing the square. An 1871 renovation added a mansard roof and cupola and reoriented the façade to North Main Street. Visible at the far left are the roof and chimney of the Alston House. The roof and chimneys on the right side of the photograph belong to the Red House, which Robert Henry Wardlaw reported as the town's oldest building when fire destroyed it in January 1872. John C. Calhoun's law office was reportedly in this building, a claim corroborated by such reputable sources as *The Press and Banner*.

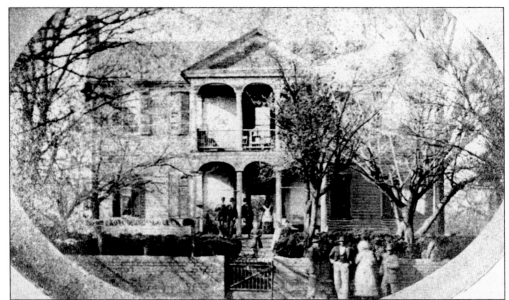

ALSTON HOUSE. James and Catherine Hamilton Alston lived in this house, constructed around 1840. Located at the northwest corner of Court Square, it replaced a smaller house where Catherine Alston's father, Maj. Andrew Hamilton, had lived. During the 1870s, five sisters known as the "Misses Cater" operated a boarding house here. Their mother, Jane Lovely Patterson Cater, wife of Richard Bohun Cater, assisted. About 1884, the house was moved back and attached to the rear of the New Hotel, later called the Glen Ethel Hotel. It burned on June 5, 1908, and was replaced by two-story buildings on North Main Street. This photograph shows the house at its original location. The girl on the front walk is Hattie Belle Cater. (Courtesy of Rose-Marie Williams.)

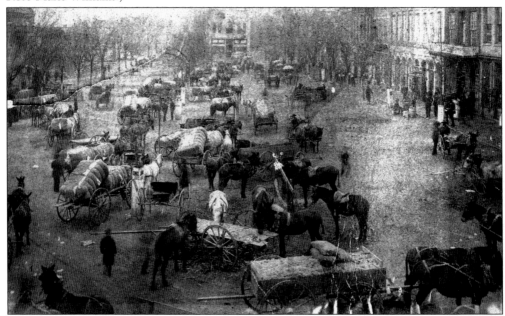

COTTON DAY, ABBEVILLE SQUARE. This late 1800s picture shows a busy day on the square. Both cotton and cotton seed were sold as well as ginned in Abbeville.

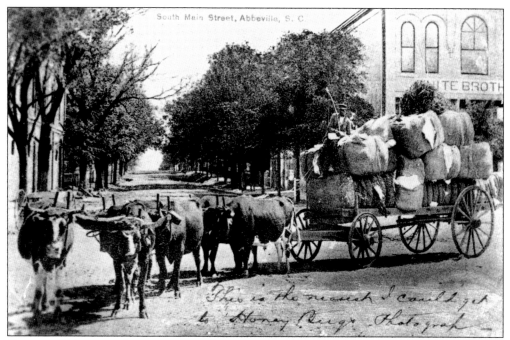

OXCART. This image, depicting an ox-drawn wagon with cotton bales, looks down South Main Street. The date of the image is unknown. (Courtesy of Charles F. Johnson.)

LAW RANGE. These law offices were known as the Law Range. At one time, notable figures like John C. Calhoun, Armistead Burt, Thomas Chiles Perrin, James M. Perrin, Samuel McGowan, and his partner W.H. Parker practiced law in these buildings. These buildings no longer stand.

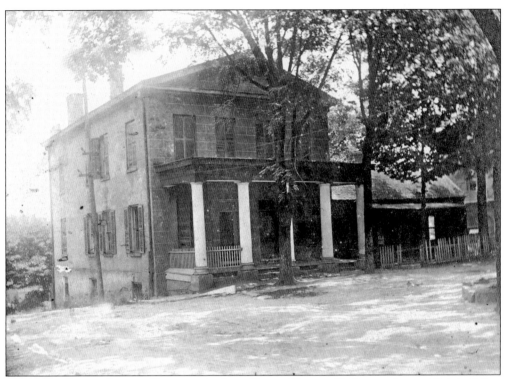

GARY LAW OFFICE. Depicted here are the law offices of Eugene B. Gary and sons. This building was torn down when the present city hall and courthouse were built.

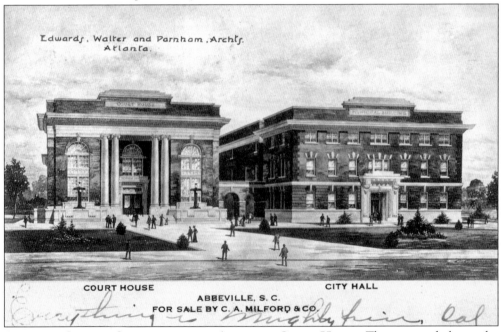

Edwards, Walter and Parnham, Archts.
Atlanta.

COURT HOUSE CITY HALL

ABBEVILLE, S. C.
FOR SALE BY C. A. MILFORD & CO.

ABBEVILLE COUNTY COURTHOUSE AND ABBEVILLE OPERA HOUSE. This postcard shows the Abbeville County Courthouse and the Abbeville Opera House. It is noted that this card was for sale by C.A. Milford & Co. *c.* early 1900s.

ABBEVILLE SQUARE. This old photograph from the late 1800s shows the Abbeville town square facing south.

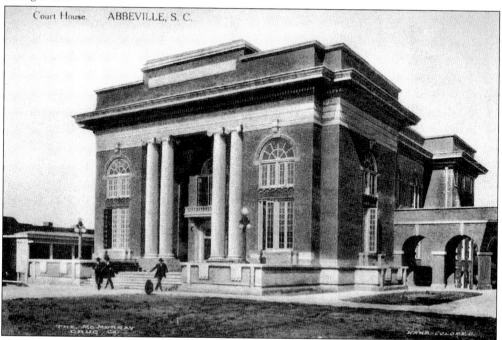

Court House. ABBEVILLE, S. C.

COURTHOUSE POSTCARD. Another postcard of the Abbeville County Courthouse, this card was sold by the McMurray Drug Company.

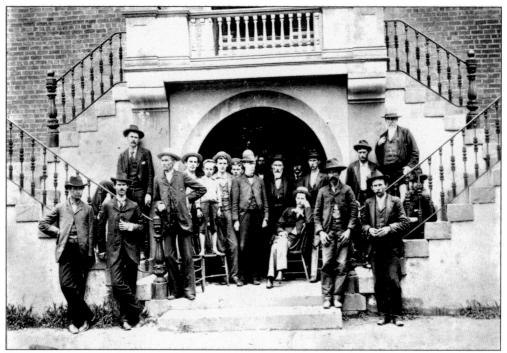

CITIZENS' MEETING. A group of citizens gathers in front of the Abbeville County Courthouse in the early 1900s. Identified on the picture are Robert S. Wardlaw, L.W. Smith, M.L. Bowen, John T. Parks, W.D. Mann, M.G. Zeigler, James M. White, J.F.C. DuPre, P.B. Speed, J. Fuller, L.W. Connor, J.C. Klugh, F.B. Gary, S.C. Hodges, Andrew Lyon, and Hertford Parks.

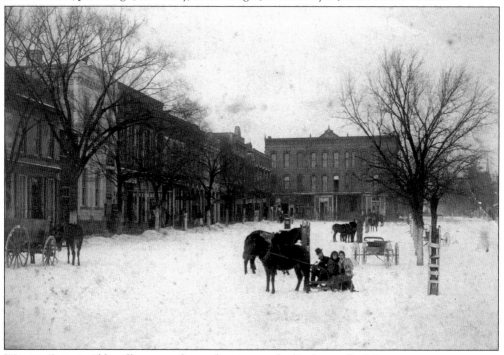

WINTER SCENE. Abbeville square faces what is now the Exchange Building.

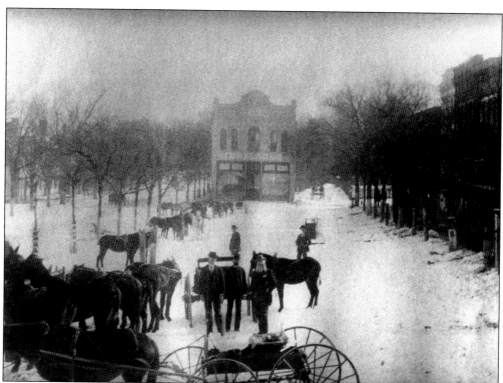

ABBEVILLE SQUARE IN SNOW. This picture of Abbeville square, taken in the 1890s, shows White's Grocery and Dry Goods. The powder magazine from the Revolutionary War period was in an open space on the right side of White's store. This picture was provided by James Blanning White of Abbeville, a descendant of the owner of White's business. The original plat to the first powder magazine was given to the Caroliniana Library at the University of South Carolina. (Courtesy of James B. White.)

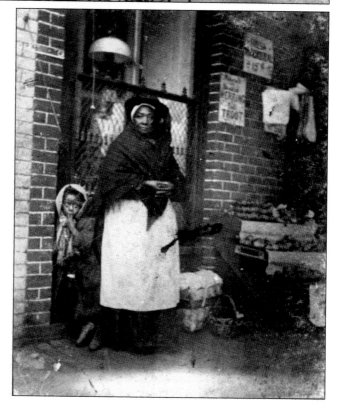

WOMAN ON SQUARE. This late 1800s picture depicts an unidentified woman and her child on the square in Abbeville.

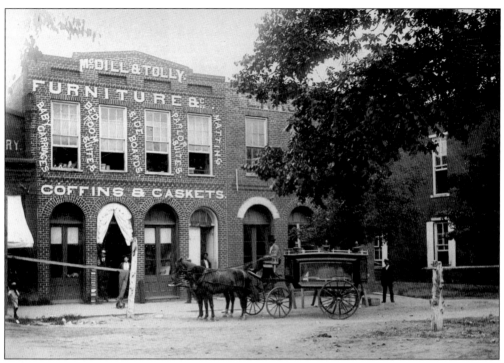

COFFIN STORE. McDill and Tolly Coffins and Caskets was located in Abbeville town square.

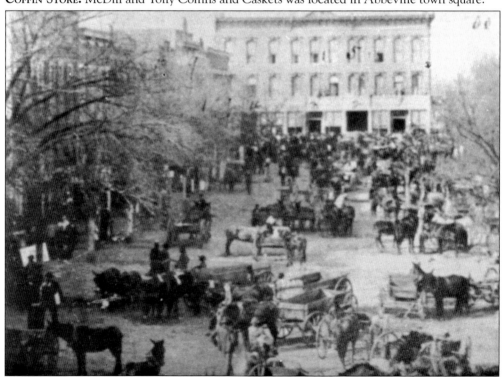

TOWN SQUARE. The caption of this old picture of Abbeville reads "The Town of the State." The image is dated Saturday, December 22, 1894.

CONVERSATION ON THE SQUARE. A group of Abbevillians meet on the Court Square, facing North Main Street. The building on the left later became the Belk store.

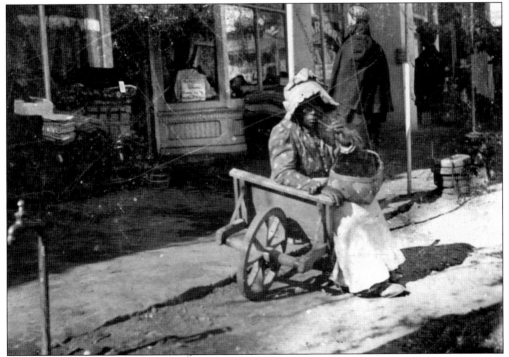

LADY ON SQUARE. This picture from the late 1800s shows an unidentified woman sitting on the sidewalk on the square in Abbeville.

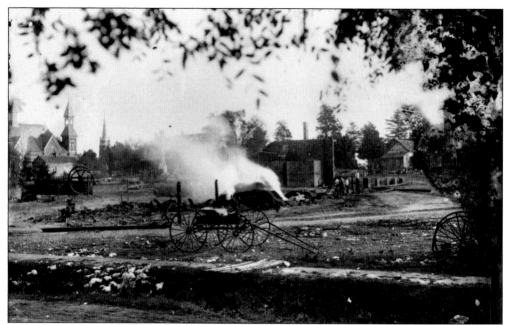

ABBEVILLE FIRE. This view from Church Street shows buildings after the fire of June 5, 1908. The churches in the background are Abbeville Presbyterian and Main Street Methodist. Three great destructive fires hit Abbeville in a period of a little over 12 months between 1872 and 1873. The fires resulted in the loss of much property, including the beautiful 40-room Marshall House Hotel, which was valued at $15,000 but insured for only $3,000.

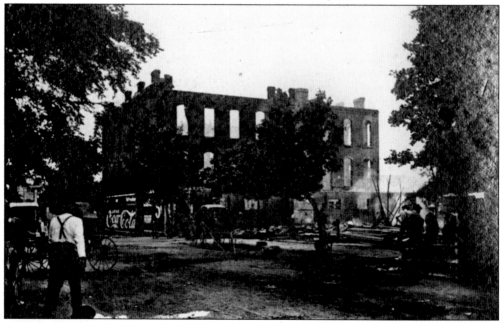

ABBEVILLE FIRE. Shown here are the remains of the New Hotel (later known as the Glen Ethel Hotel) after the June 5, 1908 fire in Abbeville. To the right are the remains of the Alston House, which was a much older, wooden two-story. It had been moved and attached to the hotel before the fire.

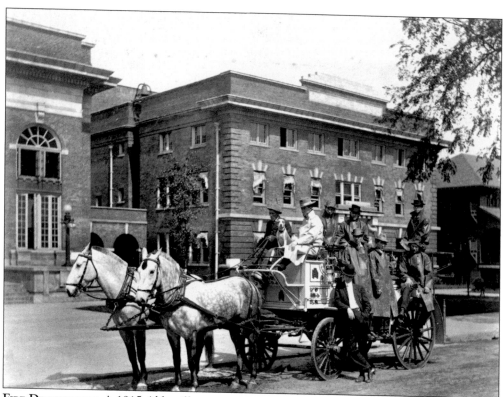

Fire Department. A 1915 Abbeville fire squadron poses in front of the Opera House and courthouse. The 15 white and 50 African-American firemen were all volunteers. Ray Mckenzie is on the front right, and Joe Elgin, a druggist for McMurray's Drug Store, is on the front left. Ernest Pennel stands with his foot on the front wheel, while Albert Wilson leans over the rear wheel. Robert L. Mabry Jr. stands on the rear deck, ready with the hose. The horses were named Mutt and Jeff. The fire alarm bell, "Big Bob," can be seen at the top left of the building.

Big Bob. This alarm bell was acquired during the term of Robert McGowan Hill, who was the mayor of Abbeville from 1892 to 1898. The bell was named for him.

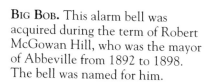

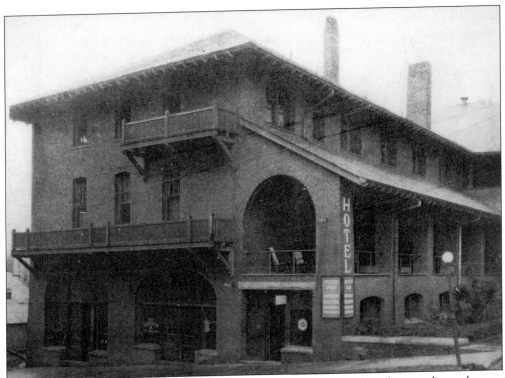

EUREKA HOTEL. The Eureka Hotel was built in 1903 to accommodate the traveling salesmen and railroad men who had layovers in Abbeville. It became the Belmont Inn in 1938 and was closed from 1972 to 1983. It reopened as the Belmont Inn once again in November 1984..

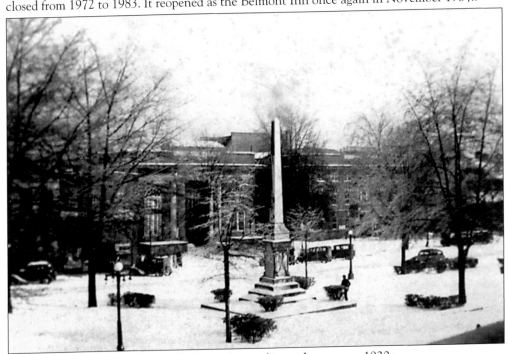

BLEAK MIDWINTER. The Abbeville Court Square lies under snow, *c.* 1920s.

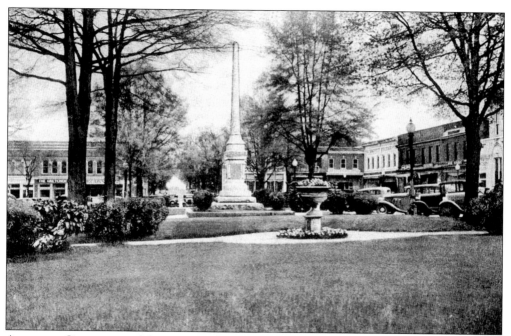

ABBEVILLE CONFEDERATE MONUMENT. The monument is shown here in 1925.

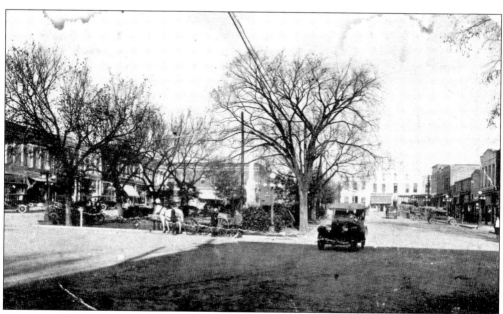

ABBEVILLE PLAZA. The Abbeville square is depicted here in the 1920s.

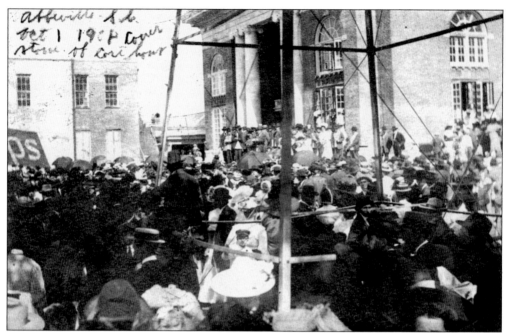

CORNERSTONE OF THE COURTHOUSE. This ceremony was held on October 1, 1908, for the placement of the cornerstone for the Abbeville County Courthouse.

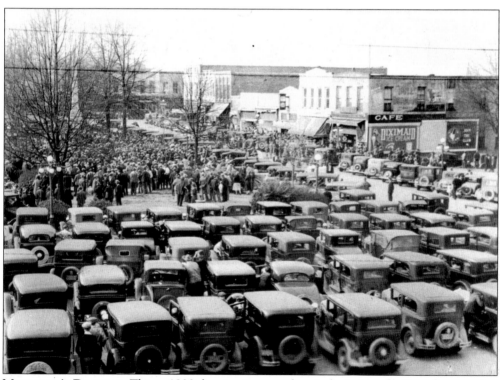

MERCHANT'S DRAWING. This *c.* 1929 drawing is a merchant's depiction of a Saturday morning on Court Square in Abbeville.

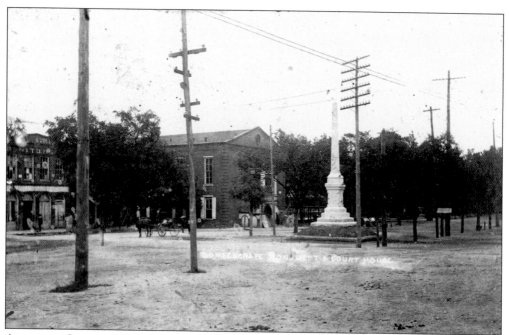

ABBEVILLE SQUARE. This photograph shows the Abbeville square, *c.* 1906. Included in the view are the monument and the fifth Abbeville County Courthouse; the current courthouse is the sixth.

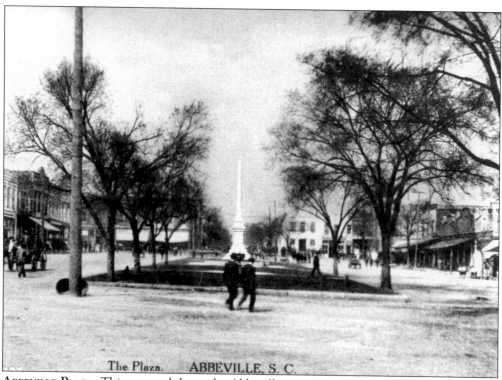

The Plaza. ABBEVILLE, S. C.

ABBEVILLE PLAZA. This postcard shows the Abbeville square in the early 1900s.

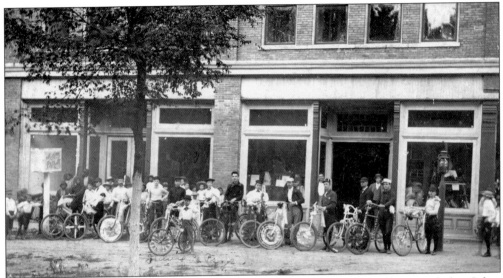

BICYCLE CLUB. Shown here is an early picture of a group of young Abbevillians, including Julius DuPre (the child in the forefront). The buildings in the background are currently the Hite-Pruitt law offices and the former Dendy Corner. The old two-story Dendy home once stood here, but it was moved many years ago. The old jail, which is currently a museum, also occupied the space. The sign to the west says Ice Cream Parlor. Notice the old gas lighting on the right. (Courtesy of Adelaide DuPre.)

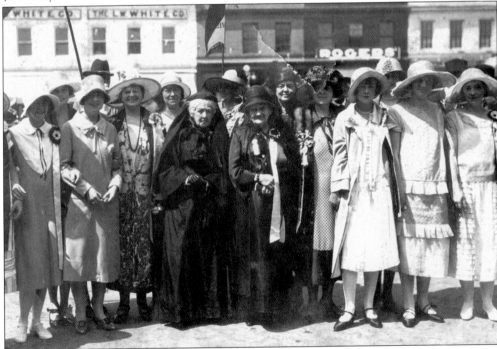

CONFEDERATE WIDOWS. Mrs. Fannie Marshall, the widow of a Confederate soldier, is shown here in this c. 1920s photograph when she was almost 100 years old (front row fourth from left). The event was a local United Daughters of the Confederacy celebration. The building that can be seen in the background, the L.W. White Company, is now the Phoenix Café.

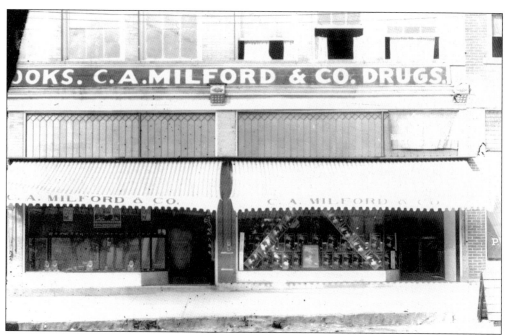

Milford Store. This drug store was located on the square. It is believed to be where the League of the South is now located.

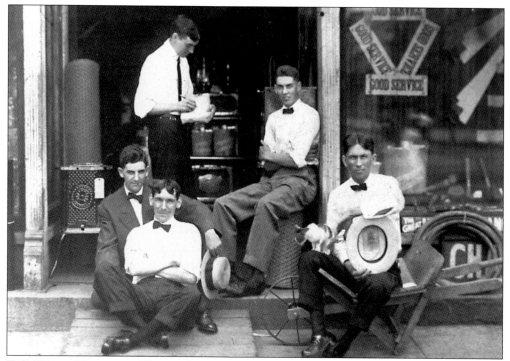

T.G. White Hardware. This 1915 image shows the front of T.G. White Hardware store on the square. Pictured in the front row, from left to right, are Will Harris, Vic Lomax, and Bob Mabry Jr. The top two individuals remain unidentified. Edith's is now located where the hardware store used to be.

PRESSLEY. Clarence E. Pressley is shown with his beloved 1931 Model A Ford, which was purchased from Robert Cheatham. Mr. Pressley was a respected businessman and community leader. A street in Abbeville was recently named in his honor. (Courtesy of Gloria A. Pressley, Hampton, Virginia.)

THE WHITE SISTERS. Tina and Mamie White were the daughters of Tina and Paris White of Abbeville.

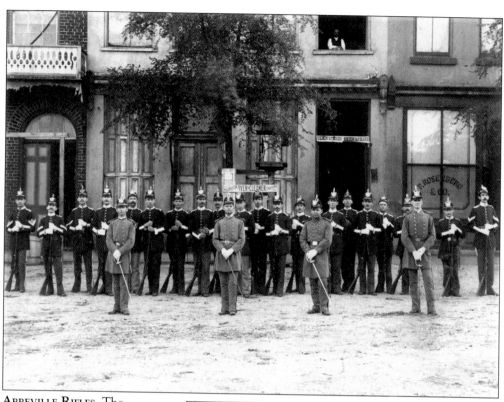

ABBEVILLE RIFLES. The Abbeville Rifles are pictured in front of the P. Rosenberg & Co. store *c.* 1890.

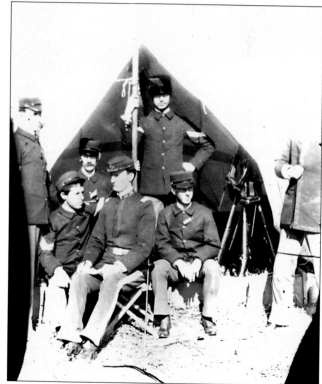

SPANISH-AMERICAN WAR, 1890s. This group volunteered in the Spanish-American War. It is believed that the man seated front and center is Captain ? Milford, who owned Milford's Pharmacy in Abbeville.

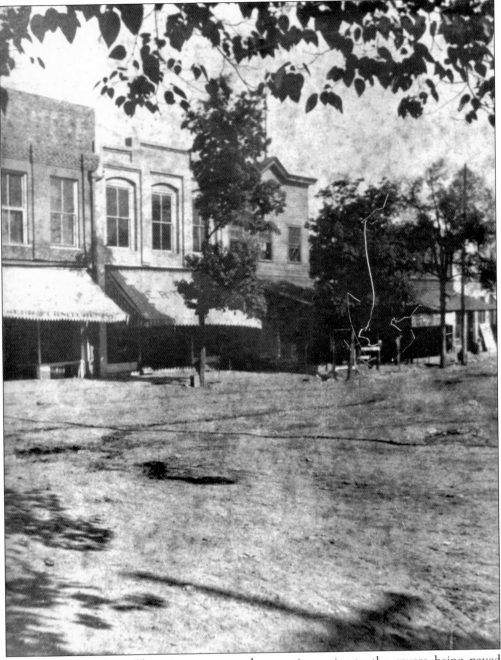

COURT SQUARE VIEW. This picture was made sometime prior to the square being paved with brick.

Four

OLD ABBEVILLE
Portrait of the South

Abbeville grew up around a gracious, tree-lined square. The right-hand side of the square is dominated by a pair of handsome brick buildings, the courthouse, and the elegant Opera House. In the center of the square is the Confederate Monument. The square is the starting point of the Abbeville Historical District.

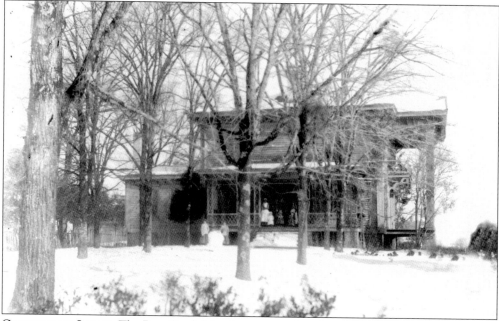

CONFEDERATE LODGE. The Burt-Stark Mansion, once referred to as Confederate Lodge, was the site of the last organized meeting of the Confederacy on May 2, 1865. Burt's friend Jefferson Davis was in attendance. Designated a National Historic Landmark in 1993, the house was built in the 1830s by David Lesley. By 1865, Maj. Armistead Burt owned the house; his wife, Martha, whom he married in 1832, was a niece of John C. Calhoun. The James Stark family purchased the house in 1913, and his twin daughters, Mary Stark Davis and Fannie Stark McKee, were the last residents.

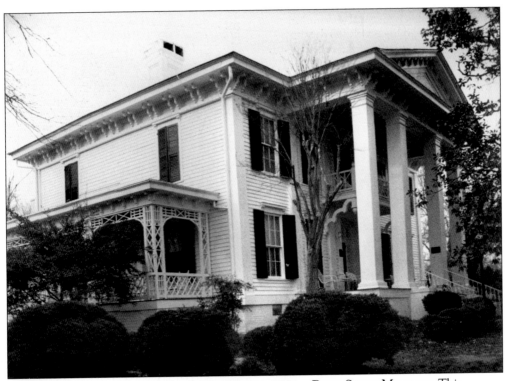

BURT-STARK MANSION. This famous house was built in the Greek Revival style and is furnished with antebellum antiques. The house is known for its hospitality and is preserved for future generations by the efforts of the Abbeville County Historic Preservation Commission.

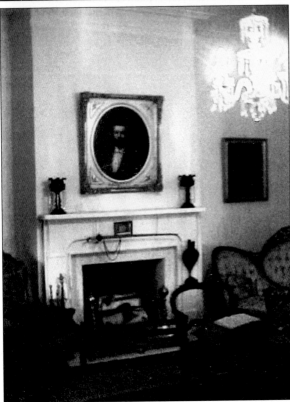

BURT-STARK PARLOR. The gentlemen's front parlor of the Burt-Stark Mansion was the location of the Council of War meeting of the Confederacy. Confederate president Jefferson Davis was in attendance at this meeting, held on May 2, 1865. The portrait over the mantle is of Samuel Stark, the father of Jim Stark. Jim bought the house in 1913.

THE STARK FAMILY. James and Ann Miller Stark are pictured here with their only children, twin daughters, Fannie and Mary.

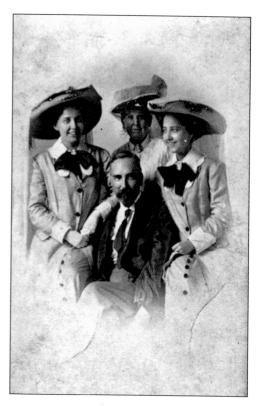

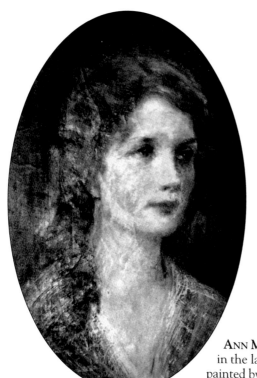

ANN MILLER STARK. Ann Miller Stark's portrait hangs in the ladies' parlor of the Burt-Stark Mansion and was painted by the renowned artist George Aid. Ann was the wife of James Stark.

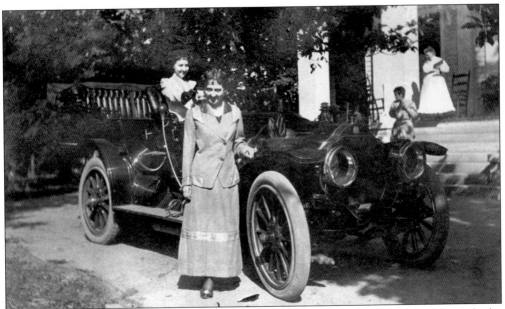

STARK FAMILY WITH CAR. Shown in this 1908 picture are Mary and Fannie Stark with the family car, a Garford. Mrs. James Stark is on the steps of the Burt-Stark Mansion.

MARY'S MOTHER. Ann Miller Stark is elegantly dressed in this photograph. She was the mother of Mary Stark Davis, an early owner of the Burt-Stark Mansion.

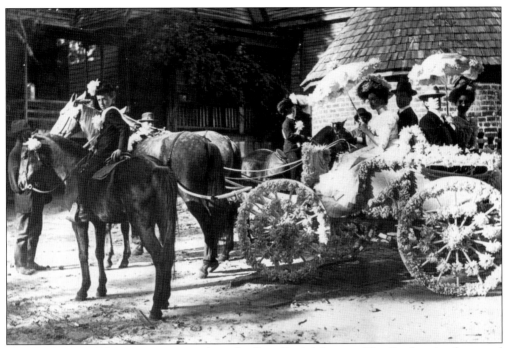

LADIES' OUTING. This picture was made at the Burt-Stark Mansion. The Stark twins decorated the buggy for a parade, but they did not get to ride in the parade. Even in her 90s, Mary Stark Davis was still fuming that she wasn't able to ride in the parade.

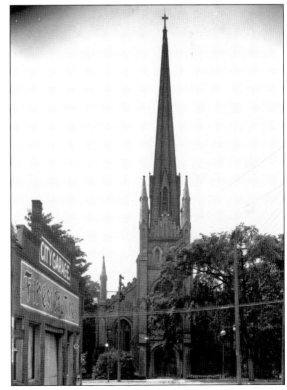

TRINITY CHURCH. This lovely old church with its tall spire was constructed in 1859 and dedicated in 1860. It is noted for its stained-glass windows, its Tracker organ, and its illustrious membership.

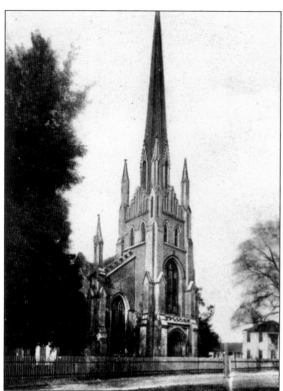

Trinity Church. Built in 1859–1860, this is the oldest church building in the city. The congregation was organized in 1842.

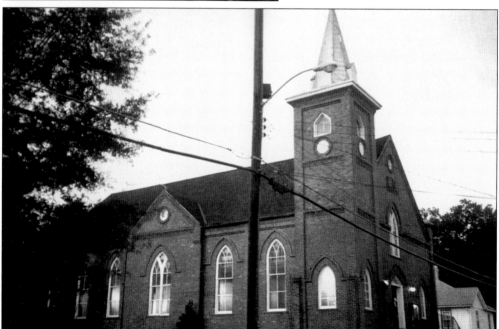

St. James A.M.E. Church. An article in *The Press and Banner* said, "In 1868, the Negro Methodist built a good school house, erected a large and commodious house of worship, and put up a comfortable parsonage." The current church building was erected in 1899 of bricks made by the church members. The church was established in 1867.

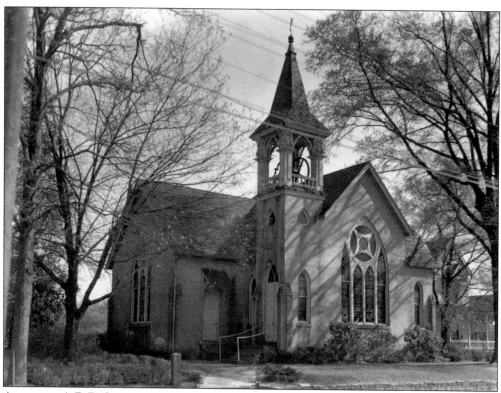

ABBEVILLE A.R.P. CHURCH.
This church was organized in 1889. The present church was erected on Vienna Street and opened for services in 1871. It was one of the first churches to have electric lighting.

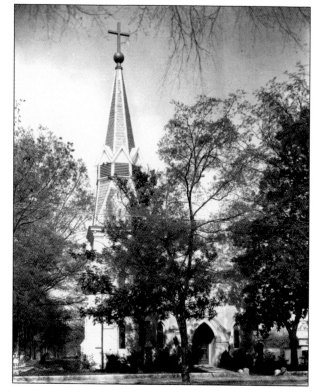

CATHOLIC CHURCH. An old photograph shows Sacred Heart Catholic Church in Abbeville. This beautiful building was completed in October 1885, and the architecture was Norman Gothic. The church was built with $4,000 from the estate of young Thomas G. Enright, a devout Catholic who died in 1883.

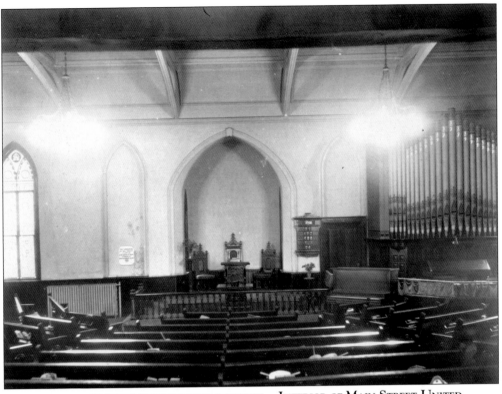

INTERIOR OF MAIN STREET UNITED METHODIST CHURCH. Established in 1826, this is the oldest church congregation in Abbeville. The current building, which was the third one built, dates to 1887. Many of the changes that the building has undergone may be seen from the exterior of the church.

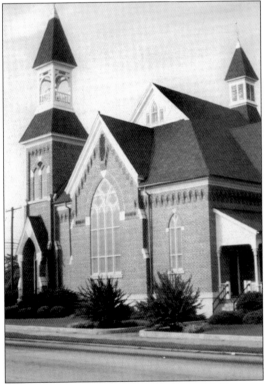

ABBEVILLE PRESBYTERIAN CHURCH. Established in 1853, this church was erected in 1888, the same year L.W. White built his new store. White also helped oversee the construction of this church. The building contains beautiful stained-glass windows, installed at a cost of $600 at the time the building was erected.

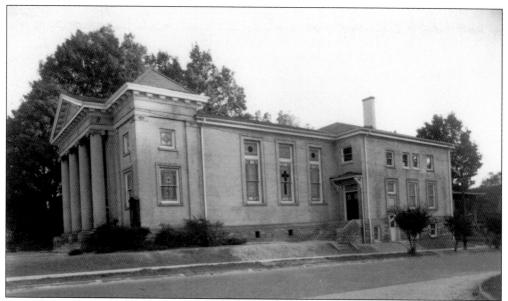

BAPTIST CHURCH. The First Baptist Church of Abbeville was built on the site where the Presbyterian church stood and burned in 1887. The Baptist church was organized in 1871, and the first building stood on the corner of West Pinckney and Church Streets.

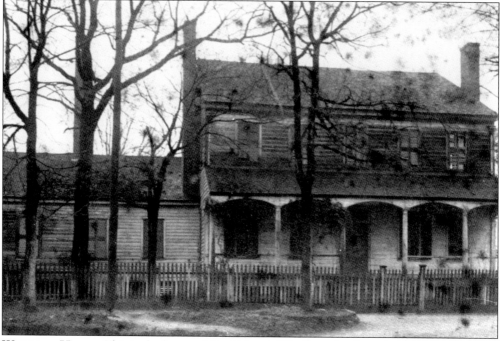

WARDLAW HOUSE. This is the house of David Lewis Wardlaw, the first white child born in the Abbeville District, in 1799 in the Quay Tavern. He was a delegate to the Secession Convention in 1861, a law partner to Patrick Noble, and Gen. Samuel McGowan's father-in-law. His home was bought by Leonard W. White, and the White family lived there until it was torn down in 1904. This is the current site of the Harris Funeral Home, which was the White family home until 1932. (Courtesy of James B. White.)

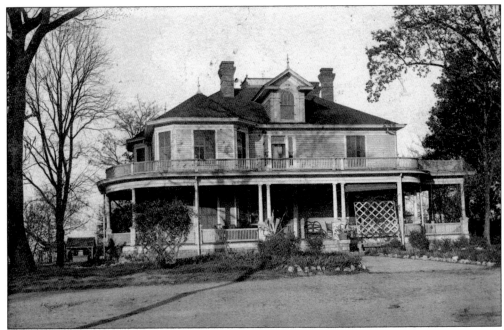

HARRIS HOUSE. This house was built in 1904 and is now the Harris Funeral Home. Noted Abbeville businessman L.W. White had this house built for his family. The structure was sold to Will Harris in 1937 for his funeral home business and has remained a funeral home since 1937. (Courtesy of James B. White.)

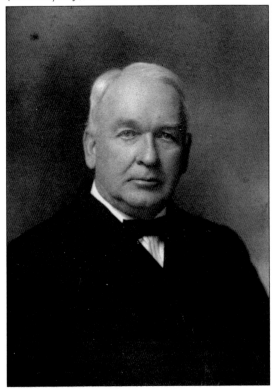

L.W. WHITE. Pictured is noted Abbeville businessman L.W. White about 1898. He was the owner of White's Hardware (where Edith's is now located) and a dry goods and clothing store (where the Phoenix is now located). He also sold Model T Fords. (Courtesy of James B. White.)

ABBEVILLE BASEBALL NINE. In 1896, T.H. White and W.H. White (father of James B. White) were the pitcher and catcher (respectively) for the semi-pro team called the Baseball Nine. (Courtesy of James B. White.)

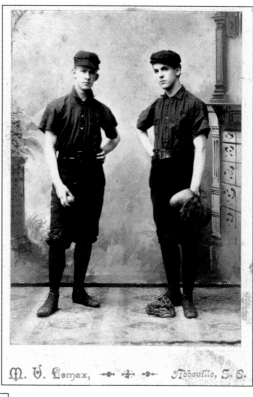

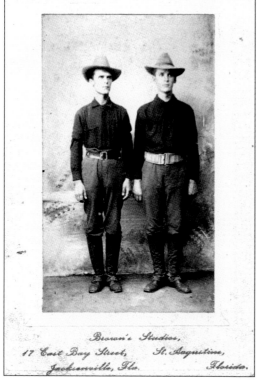

SOLDIERS. W.H. White and Lewis Perrin are depicted during the Spanish-American War in 1898.

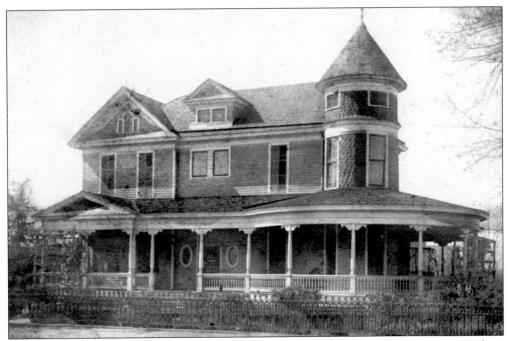

GOODE-THOMSON HOUSE. The Thomson House stood on North Main Street across from Sacred Heart Church. Adelaide Little DuPre was born in this house, which belonged to her grandparents. It was built in the 1890s and was torn down around 1946.

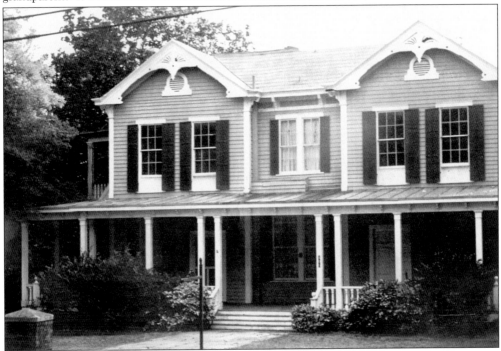

SMITH-VISANSKA HOUSE (1882). Originally built in the Steamboat Gothic style, this house belonged to one of Abbeville's prominent Jewish families, G.A. Visanska. G.A. Visanska and Philip Rosenberg became partners in 1877, and their business interests prospered in the 1880s.

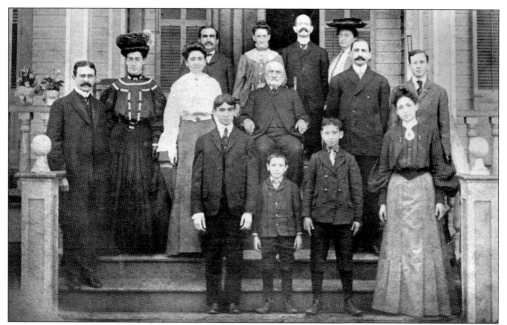

VISANSKA-ROSENBERG FAMILY PICTURE. Pictured from left to right are (front row) Solomon A. Rosenberg, Arthur P. Rosenberg, Albert H. Rosenberg, and Irene Rosenberg (Levi); (middle row) Dr. Samuel A. Visanska, Florence Mae Fuld Visanska, Belle Visanska, G.A. Visanska, Walter Visanska, and Ernest Visanska; (back row) Phillip Rosenberg, Cecelia Visanska (Rosenberg), Tulius Visanska, and Sarrah Bentschner. They are pictured in front of the family home on North Main Street.

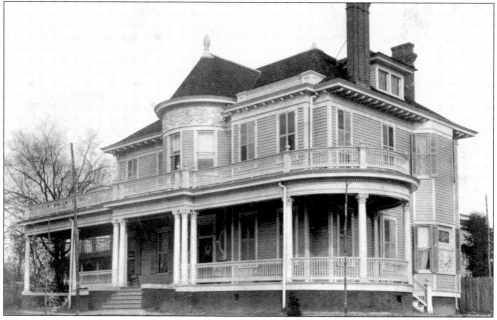

NEUFFER-WHITE HOUSE. This house was built in 1903 for the family of Dr. G.A. Neuffer, a prominent Abbeville physician from the turn of the 20th century. Notice the poles in the front and side yard, which are now big oak trees. (Courtesy of Judy and Roland White.)

NEUFFER-WHITE HOUSE. Pictured in the foyer of the Neuffer-White house on North Main Street is Dr. Augustus Neuffer holding Florence. His son Gottlob is to the right. (Courtesy of Judy and Roland White.)

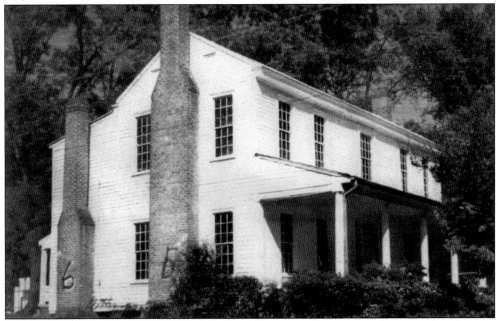

LAWSON-RUSSELL HOUSE. Built in the early 1850s by attorney Robert A. Fair and his wife, this house features nine over nine windows, indicating its early origins. It became the home of the Louis Russell family in 1871. The last resident, Miss Antoinette Russell, died in 1946. The house was acquired by the City of Abbeville and used as the recreation department for many years. It was torn down and replaced by the Civic Center on North Main Street in the 1960s. (Courtesy of Robert S. Gamble of the Alabama Historical Commission.)

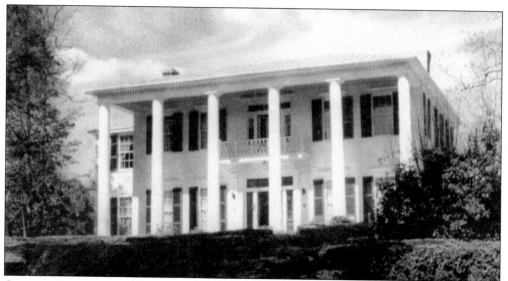

CALHOUN-SMITH-WILSON-JOHNSON HOUSE. The original house was built around 1825 and expanded to its present size by James C. Calhoun, owner from the 1840s to 1866. The boxwood gardens were planted in 1859. The home has been graciously restored by Brig. Gen. and Mrs. Ben Johnson.

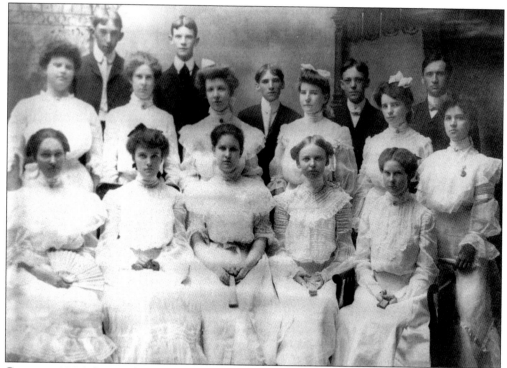

CLASS OF 1904. Pictured is the Abbeville Grammar and High School Class of 1904. From left to right are (front row) Eliza Mabry, Susie Hill, Helen Smith, Annie White, and Caro Morse; (middle row) Ione Miller, Oney Morse, Helen White, Virginia Gambrell, Sarah Simmons, and Nell Wilson; (back row) Courtney Wilson, Wallace Harris, Whitfield Cheatham, Lewis Perrin, and Professor ? Gilliam, who was the principal. (Courtesy of William G. and Linda P. Hill.)

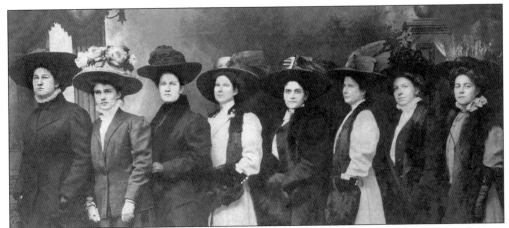

THE OLD MAIDS. Pictured in 1908 are Ione Smith, Susie Hill, Helen Smith, Oney Morse, Fannie Harris, Caro Morse, Helen White, and Lucy Henry. These women formed a club and called themselves the Old Maids, although many of them later married. Ione and Helen Smith were twins, as were Oney and Caro Morse. Susie Hill was the aunt of Dr. William G. Hill. (Courtesy of William G. and Linda P. Hill.)

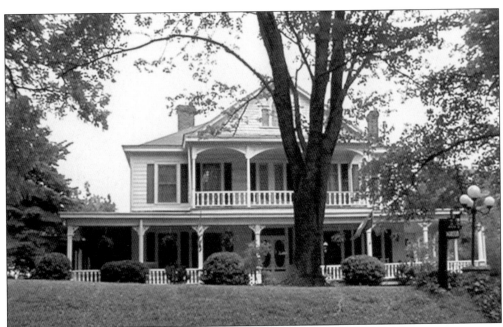

MORSE-WIER HOUSE. Mr. Amos B. Morse built this house for his family in 1883. The original outbuildings remain. The street in front of the house was once called Morse Hill, and the family was known to have some of the original Abbeville gas lights on either side of their front walk. These have been saved and copied and can be found in almost exact replicas in front of the Abbeville County Historical Society's headquarters, as well as at other homes.

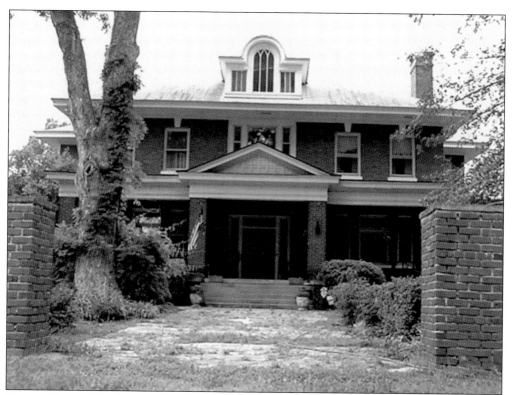

PERRIN HOUSE. This large, red brick house was built in 1912, and it has been described as the first modern house built on this block as the surrounding houses were much older. Dr. and Mrs. David Martin own this property now.

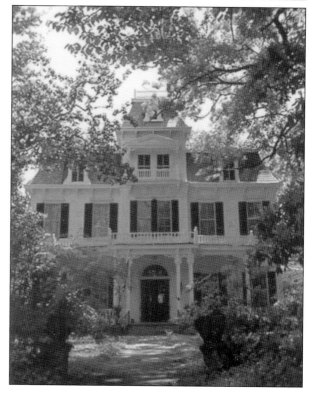

LEE HOUSE. Built in 1885, this is Abbeville's most outstanding example of Second Empire architecture. The house was built for William A. Lee, who was editor of the local newspaper. The home, which was first restored by Buddy and Marilyn Reid, is currently owned by the Thomas E. Hite family.

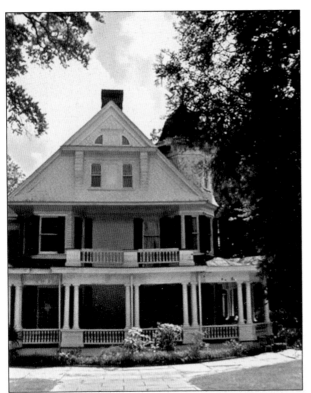

C.D. BROWN-NEUFFER HOUSE. Built in the early 1900s for Mr. C.D. Brown, a depot agent for the Seaboard Airline railroad, this home is designed in a style of architecture that included the end of the Queen Anne period and the beginning of the Edwardian period. The house belonged to the noted historian Helen Ladd Neuffer and is currently occupied by her daughter, Mary Chase Neuffer Ford.

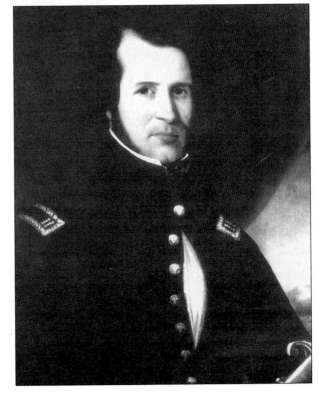

COL. J. FOSTER MARSHALL'S PORTRAIT. Marshall was killed in 1862 at the battle of Second Manassas. He was second in command of Orr's Rifles Regiment when it was organized in 1861, and he later assumed command of the regiment. Marshall also served as a captain during the Mexican War. In 1850, when he was 31 years old, he was a state senator and owned real estate valued at $15,000. By the 1860 census, he was an attorney worth between $128,700 and $188,005, a very large sum of money for the time!

PORTRAIT OF MRS. J. FOSTER MARSHALL, 1823–1868. Elizabeth Marshall was the mother of six children: William, Samuel, Foster, Quitman, Ida, and Mary. Mrs. Marshall remained in Abbeville after the death of her husband during the Civil War. She died in 1868 at the age of 45.

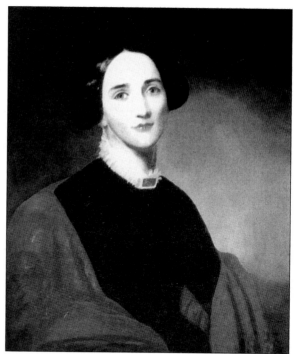

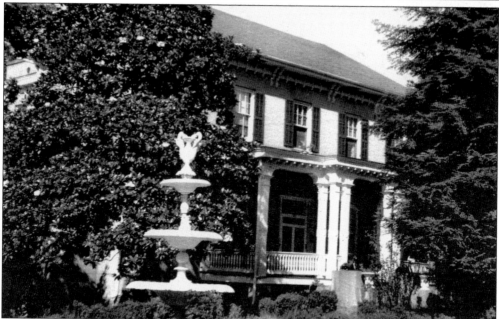

ROBERTSON-HUTCHINSON HOME. This house was built in 1881 in the Italianate style on the site of an earlier Greek Revival house that burned. The first house was built for J. Foster Marshall before the Civil War. Maj. Armistead Burt spent the last years of his life in this house with the Robertsons, relatives of his wife. The fountain in the yard was original to the first house, as were the iron greyhounds that faced the entrance to the house. This property includes the oldest and largest redwood tree in South Carolina and is the home of May and Rufus Hutchinson. (Courtesy of May Hutchinson.)

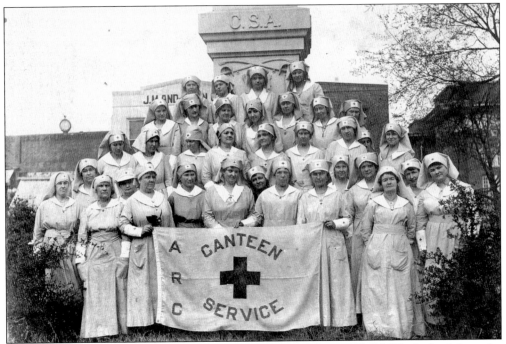

CANTEEN LADIES OF THE AMERICAN RED CROSS. Pictured during World War I, third from the left in the third row, is Eugenie Robertson (nee Baskin). May Robertson is holding the left side of the banner. (Courtesy of May Baskin Hutchinson.)

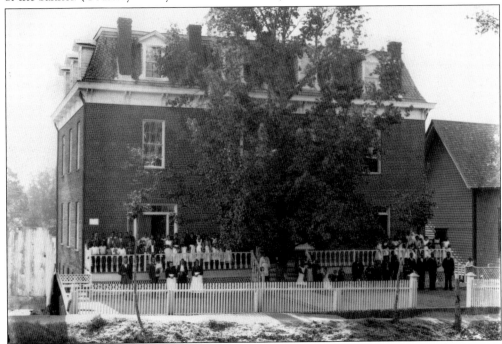

FERGUSON-WILLIAMS SCHOOL. This school for African-American girls was dedicated in June of 1894. It was built by the Second Presbyterian Church two decades prior to being converted into the Abbeville Memorial Hospital.

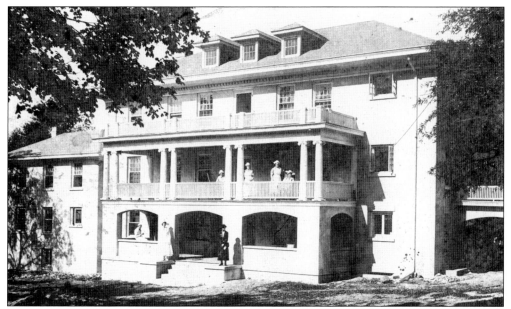

ABBEVILLE HOSPITAL. The old Abbeville Hospital on Ellis Avenue was previously the Ferguson-Williams School. This hospital served generations of Abbeville citizens before the current hospital was built in the 1960s.

HILL FAMILY. This picture was made in front of the Hill House, which was built by David Lesley. The house was acquired by the Hill family in 1893 from the Nicholas Miller family. Pictured in this 1896 photograph are, from left to right, (front row) John Livingston Hill, John Livingston Hill Jr., and Susan Tallulah Riley Hill, holding Mary Elizabeth Hill; (back row) David Hugh Hill, Samuel Thomson Hill, William G. Hill, a neighbor's child, Susan Anna Hill, and another neighbor's child. This photo was made before the Hills' youngest child was born in 1899. (Courtesy of William Greene Hill and Linda Pound Hill.)

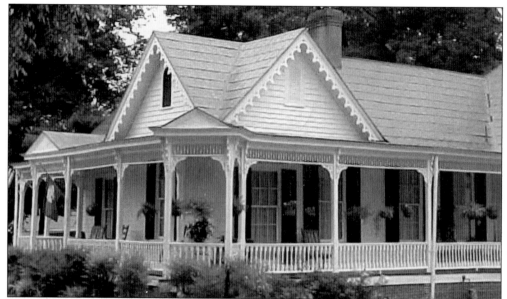

GARY-AIKEN-TAFTA HOUSE. In 1881, Mrs. Hiram Tusten deeded to her daughter, Eliza, one and a quarter acres. Eliza and her husband, Eugene B. Gary, built this house on the property at 306 Greenville Street. Gary, a member of the South Carolina Supreme Court, later became its chief justice. In 1893, the Garys sold the property, which was purchased again in 1895 by the D. Wyatt Aiken family, who owned it until 1926. The current owners, Danny and Mary Ann Tafta, have fully restored the property.

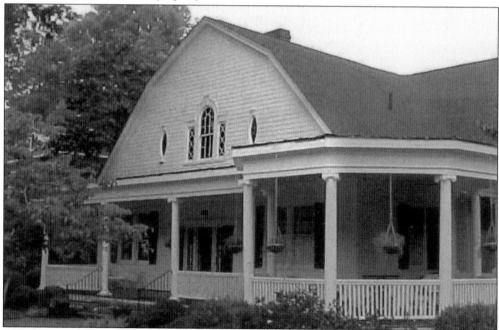

LYTHGOE-BARNWELL HOUSE. Built in the 1880s near the present Abbeville Presbyterian Church, this house was moved in 1887 to this site. The house was extensively renovated by the Barnwell family in the early 20th century with the addition of a Dutch gambrel roof and Palladian windows. It is currently the home of the David Whitmire family.

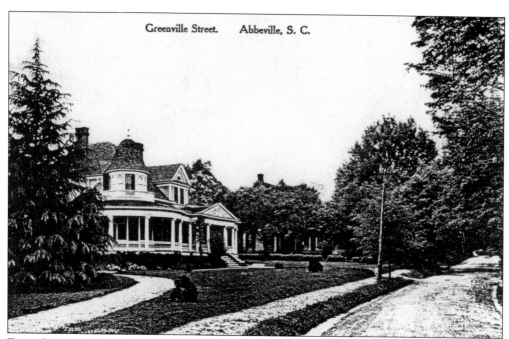

Greenville Street. Abbeville, S. C.

ELLIS-COLEMAN-ROSENBERG HOUSE. Built around 1905, this Queen Anne–style house was located behind the Burt-Stark Mansion on Greenville Street. Several of the first owners found the house too large for their needs and lived there only a short while. Dr. George Rosenberg and family were the last residents before the house was acquired by the City of Abbeville. It was torn down in the 1970s, and Jefferson Davis Park is located there today.

THE FLYNN SISTERS. Nell Flynn (Nickles), left, and Margaret Flynn (Bowie) are pictured about 1914. The Flynn sisters, daughters of Mr. and Mrs. George Flynn, remain residents of Abbeville. Margaret Flynn Bowie, at age 94, is still active as chairperson of the Abbeville County Historic Preservation Commission, which is charged with the preservation of the Burt-Stark Mansion.

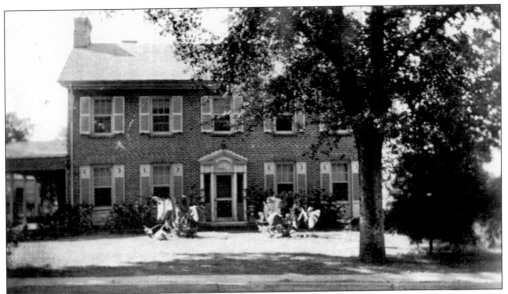

WILL WHITE HOUSE. Architect James C. Hemphill built this house in 1930–1931 for Abbeville businessman Will White in the Georgian style. This Greenville Street house has been the home of Bill Rogers since 1979 and has undergone recent preservation.

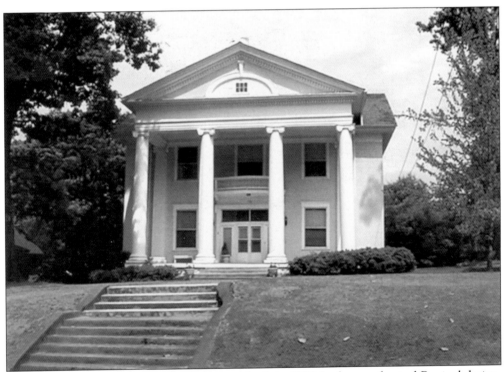

GARY-LITTLE-DUPRE HOUSE. This house was built in 1905 in the neoclassical Revival design. Mrs. Adelaide Little DuPre occupies the house today.

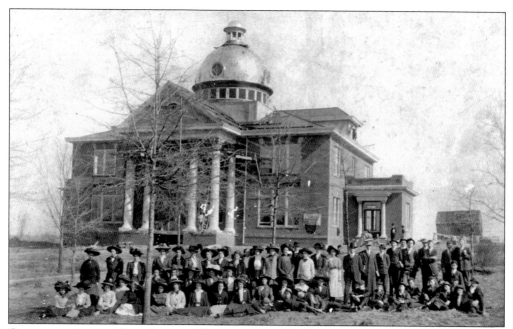

GREENVILLE STREET HIGH SCHOOL. This was an early high school building that later burned. It was on the site of the current Abbeville School District Administration Building. Adelaide DuPre remembers that when the wind blew, the windows rattled! (Courtesy of Adelaide DuPre.)

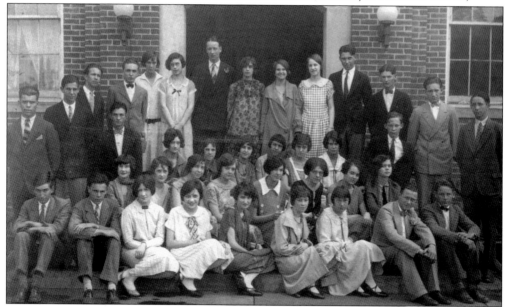

GRADUATING CLASS, 1926. Here is the Abbeville High School Class of 1926. From left to right are (first row) Julian? Ellis, Horace McAllister, Margaret Flynn (Bowie), Mary Bruce, Alma Gaston, Margaret Stallings, and Otis McMurray; (second row) Elizabeth Beeks?, Hap Neuffer, George Telford, Anna Jones, Sara Cowan, Thelma Baukknight, Margaret Penney, and Buster Howie; (third row) Edith Grubb, Annie Cheatham, Pat Howie, Walter Huckabewe, Earle White, Lucy Thompson, Warren Carter, and Earle White; (fourth row) Grace White, Lucille Gregory, James Grubb, James Graces?, and Francis Jones. (Courtesy of John C. Blythe.)

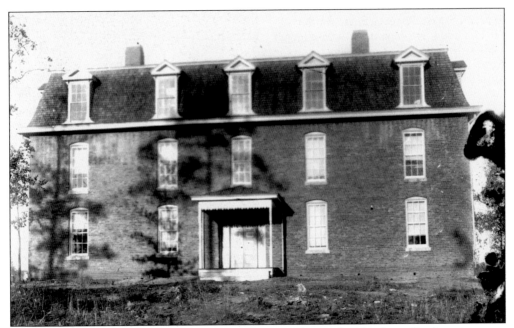

HARBISON COLLEGE BUILDING. Harbison College was begun by Northern Presbyterians as a school for African-American children. In 1903, the *Abbeville Medium* reported that Harbison College had 337 students with 187 of them boarding. Contributions that year exceeded $10,000 with $4,000 coming from students. All but the president's house burned on March 17, 1910, under mysterious circumstances.

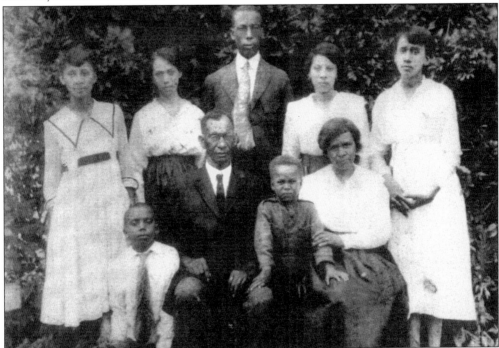

REV. C.M. YOUNG. Rev. C.M. Young and his family are pictured here. He was the president of Harbison College around 1910. President Young was a native of Due West.

REBECCA SMITH. Rebecca Scott Smith and her son, Lewis, are depicted in a photograph made around 1915. She was a teacher in the Abbeville County schools for at least six decades. She lived to be 104.

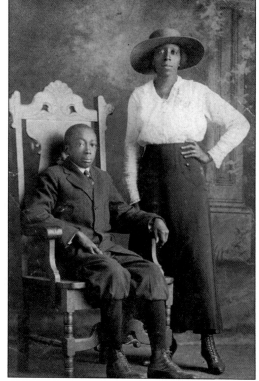

MONTEVINO. Montevino was the home of Dr. Joseph Togno, who came to Abbeville to pursue his dream of growing wine grapes. In Abbeville, he was a noted physician and writer in the field of medicine. In the 1840s, he built Montevino, which was surrounded by vineyards. It was later known as the "Rock House," and the remains of the house are found on Secession Avenue.

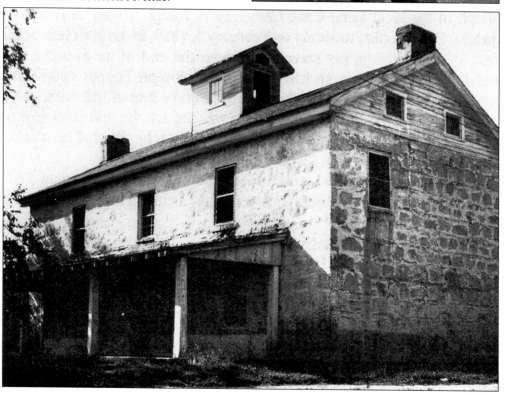

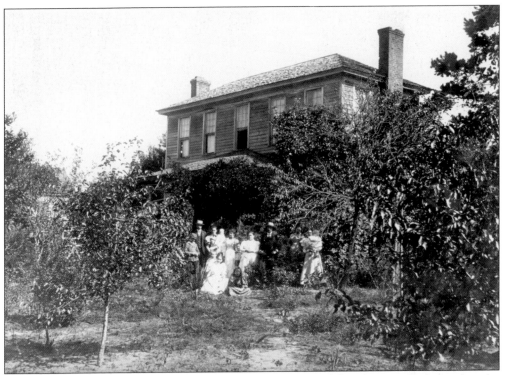

HEMPHILL. Robert R. Hemphill and his family pose in front of their home, which stood in the Fort Pickens area of Abbeville. The Little River Electric building now stands at this location.

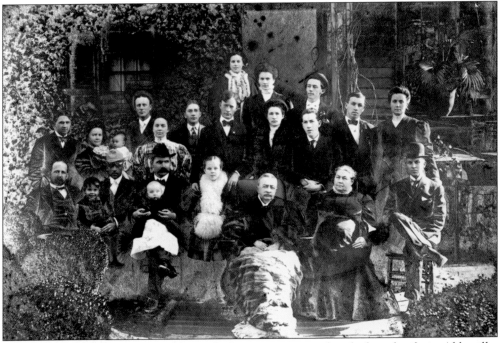

HEMPHILL. Robert Hemphill and his wife, Eugenia, are seated with their family in Abbeville. R.R. Hemphill was the editor of the *Abbeville Medium*.

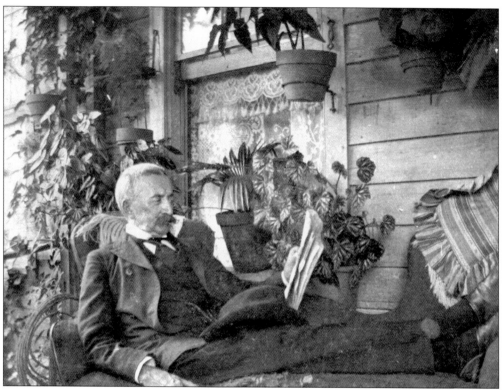

ROBERT HEMPHILL. Mr. Hemphill lies on a couch on the verandah of his Cambridge Street home.

MR. HEMPHILL. In this tintype of Robert Hemphill, he wears the latest swimwear of the 1890s.

DuPre-Sondley-Harvin House. This house is near Secession Hill, where the resolution in support of secession was adopted on November 22, 1860. Resident Julius F.C. DuPre was a professor of horticulture at Clemson University. The boxwood alley went from the house to Magazine Street. Those boxwoods, in excess of six feet tall, were sold to Colonial Williamsburg during the Great Depression. The boxwoods were later replaced by crepe myrtles. The Sondley and Harvin families also lived at this residence.

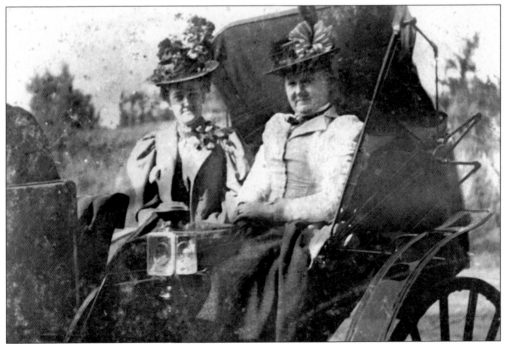

Buggy Ride. Ladies of Abbeville are out for a buggy ride. A common tradition was to stop and rein the horses, so they would prance when they came to town, making for a proper entrance.

ENOCH RAYMOND WILSON. This photograph, made in 1907, shows Enoch Raymond Wilson at age 8. He was later the owner of the Co-Operative Grocery, a business for many years in downtown Abbeville. (Courtesy of Virginia Wilson Glace.)

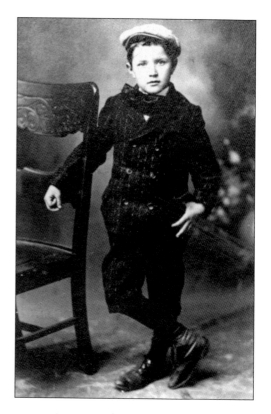

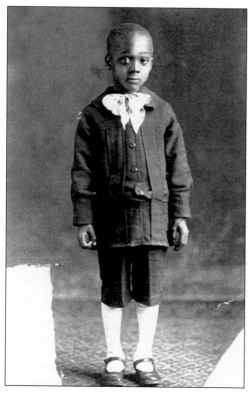

MASTER WILLIAM ADAMS. Master William Pinckney Adams is shown at about five or six years of age in 1917.

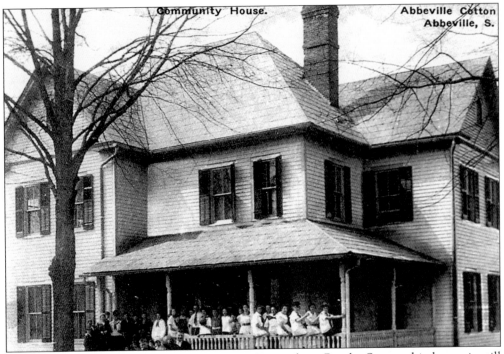

ABBEVILLE MILLS COMMUNITY HOUSE, 1917. Located on Brooks Street, this house is still standing and is currently owned by Marilyn Reid.

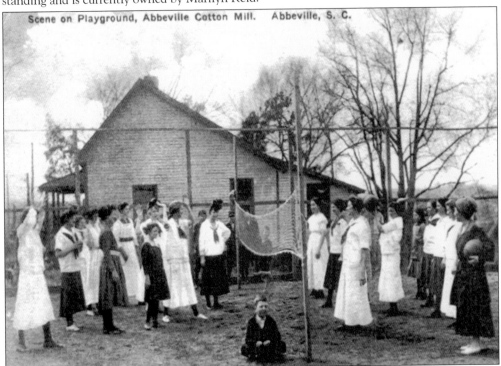

PLAYGROUND, ABBEVILLE COTTON MILL. This scene was taken on the playground at Abbeville Cotton Mill, probably around 1920. The house is on Brooks Street.

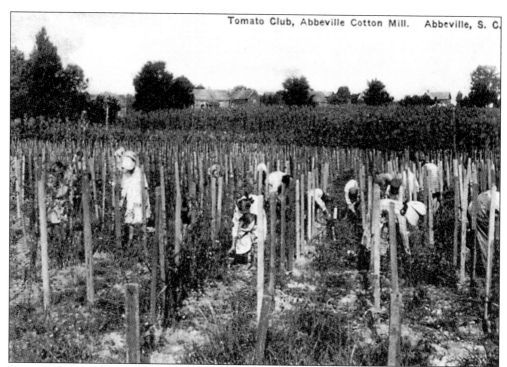

TOMATO CLUB. The Abbeville Cotton Mill Tomato Club is pictured here.

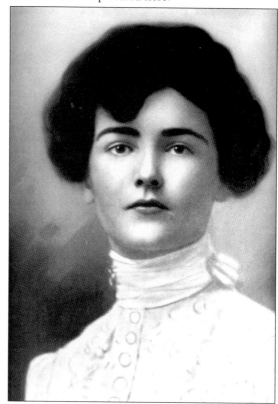

MARIE CROMER SEIGLER. This Abbeville native was elected posthumously to Abbeville's Hall of Fame. Born in 1882 on a farm located four miles from Abbeville, she died on June 14, 1965. This educator started the Tomato Club, forerunner of the 4-H Club, an organization now found throughout the United States.

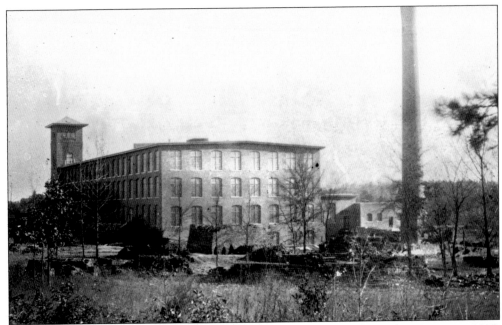

ABBEVILLE COTTON MILL. Brick for the Abbeville Cotton Mill, which began production in 1897, was made on the site. A huge steam engine was the plant's power source, and the mill boasted Draper looms of the latest design. The smokestack and elevator tower remain as landmarks. The Abbeville Plant of the Milliken Company is presently on the site.

GOING BACK TO SCHOOL. Ruth Childers (nee White), on the right, waits with an unidentified friend. They are standing in front of the Abbeville Depot on the way back to school at Allen University, c. 1923.

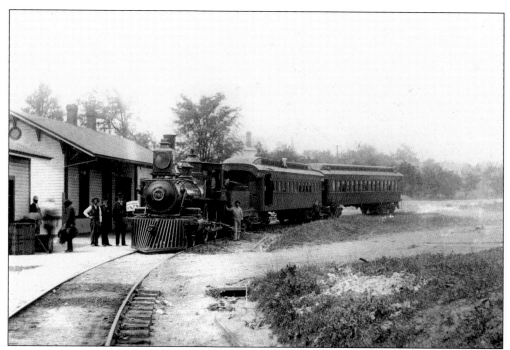

ABBEVILLE DEPOT. The Southern Railway Depot in Abbeville, built *c.* 1900, was located at the corner of Chestnut and Washington Streets. The depot later became the Kum-Bak, the famous hamburger hangout of the 1950s and 1960s.

TRAIN, 1910. The fourth man from the left in front is Mr. George Flynn (known as Boss George), who came to Abbeville in 1903. In 1907, he moved with his wife to Magazine Street. He is the father of Margaret (Flynn) Bowie and Nell (Flynn) Nickles.

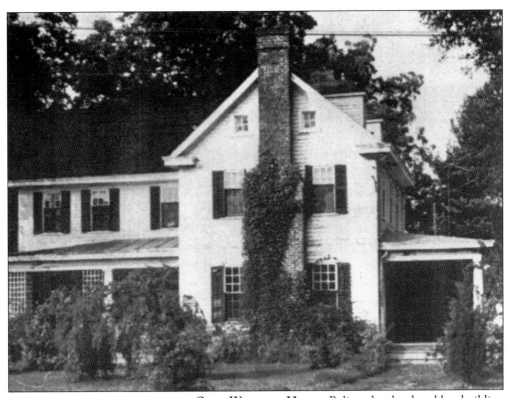

QUAY-WARDLAW HOUSE. Believed to be the oldest building standing in the city, this house contains traces of the original log cabin in the interior. It was built as a tavern and inn for travelers about 1786, and the original owner was John Quay. It was also once the home of noted Abbeville physician Dr. Claude Clinkscales Gambrell. It has been restored by Mr. and Mrs. Phillip Jones.

CLAUDE C. GAMBRELL. Born in 1872, Gambrell became a noted Abbeville physician and an original board member of the Abbeville Savings and Loan in 1907. With other local physicians, he purchased the Ferguson-Williams College for Abbeville's first hospital. He was a volunteer with the Abbeville Hook and Ladder Fire Department, formed in 1872, and was mayor of Abbeville from 1912 to 1918. He died in 1925 and has been inducted into the Abbeville County Hall of Fame.

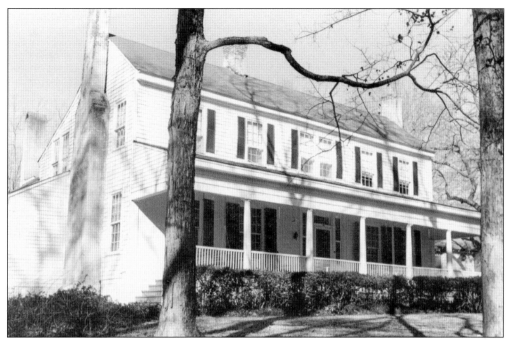

WARDLAW-KLUGH HOUSE. Only two families have occupied this stately home, built in 1831. Both patriarchs of these illustrious families were judges. Judge David Wardlaw, who built the house, fought for the Confederacy along with his 12 sons. The house remains in the Klugh family to this day.

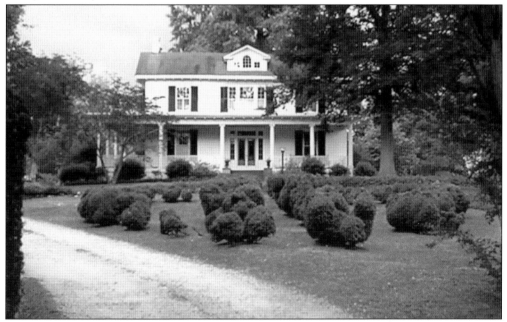

THURMOND BISHOP HOUSE. This house on Ferry Street was built around 1910. It replaced an earlier house, which had been constructed around 1855, that burned on January 12, 1910. Several outbuildings associated with the earlier house remain. Judge Thurmond Bishop, the present owner, is the nephew of the late Sen. Strom Thurmond.

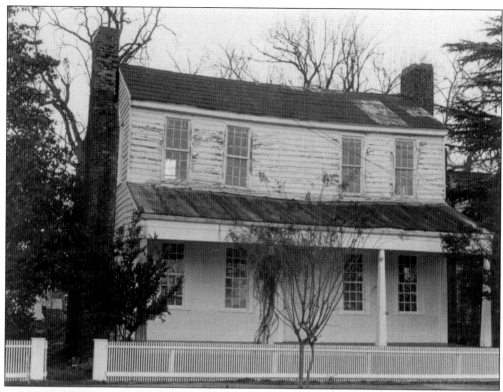

SHILLITO-TOWNSEND HOUSE. Built *c.* 1820 and thought to be one of Abbeville's earliest houses, this home was designed in the early Colonial style and has nine over nine window panes, similar to those in the Russell House. Adjacent to the house were the renowned Francis-Mahala Gardens, parts of which date to the 1820s, where Abbeville's first pecan tree, the Lawson Nut, was thought to have been planted. The garden was home to a Damask rose planted in 1828 and an unusual green rose acquired at the Japanese booth at the Philadelphia Centennial. Much of the gardens were lost in the late 1990s. The house has recently been restored by Mr. Dip Polatty and Mr. Mark Phillips.

MISS KITTY EVERETT. This is the wedding portrait of Louise Catherine Lawson Link, known to Abbevillians as "Miss Kitty" Everett. She died 100 years after she was born in the same room in the Shillito House on South Main Street in Abbeville.

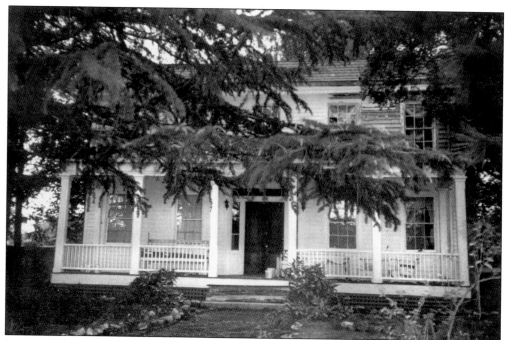

EDWARDS HOUSE. The Georgia Edwards House on South Main Street is now owned by Ruthie Harris. The house is thought to have been built in the early 1800s. A distinctive feature of the house is the cobalt blue glass sidelights at the front.

NOBLE HOME. In 1815, Patrick Noble was one of 23 people who petitioned the removal of the Abbeville powder magazine from Court Square due to the fire dangers. He became governor of South Carolina in the 1840s. This house was his summer home, and it was bought by John A. Harris on August 23, 1892, from Mary Noble, Patrick Noble, and others for $1,200.

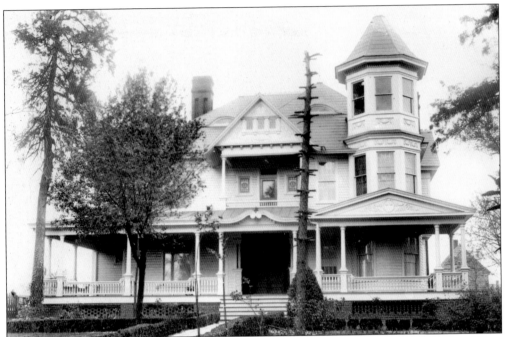

JOHN A. HARRIS HOUSE. This house was built in 1896 on the site of the summer home of Gov. Patrick Noble. It was constructed by John Harris, former president of Abbeville Cotton Mill. Many of the elegant furnishings were made in the Old Abbeville Furniture Company of which Mr. Harris was also president. The house remains in the Harris family.

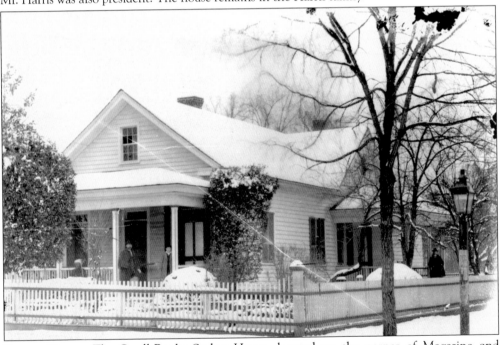

ROCHE HOUSE. The Small-Roche-Stokes House, located on the corner of Magazine and Secession Avenue, was constructed before 1878. Note the gas light in front of the house on the Magazine Street side.

OLD JAIL. This three-story building was constructed around 1854 as a jail and served in that capacity until it was replaced in 1948. The building is now the home of the Abbeville County Museum.

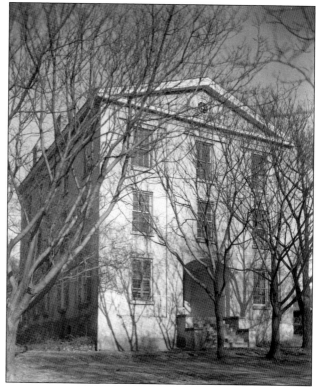

CHARLES DENDY HOUSE. This house was built *c.* 1815 and is one of the oldest houses in Abbeville. It was moved from its original location on the southeast corner (known as Dendy Corner) of the public square around 1893.

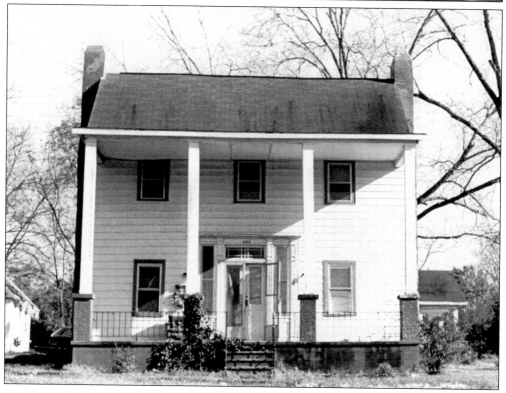

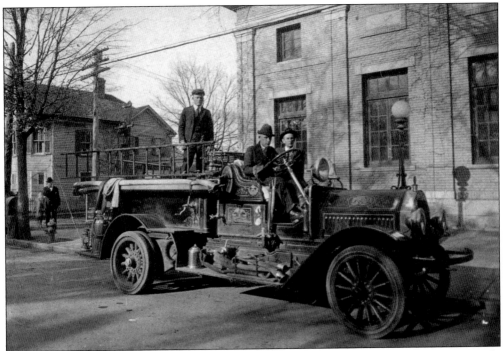

ABBEVILLE FIRE DEPARTMENT, 1915. This picture of the Abbeville Fire Department was made on South Main Street in front of the old post office in 1915.

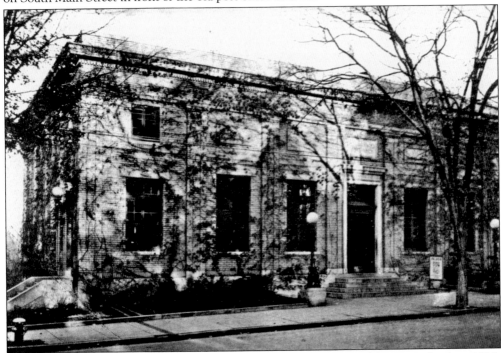

OLD POST OFFICE. Abbeville's old post office, now used as the county library, was built in 1912. It served as the post office until around 1966. Much of the interior detailing has been preserved, including the marble trim.

Five

CALHOUN FALLS
Gateway to Lake Russell

The town of Calhoun Falls was organized in the late 1890s when a group of Anderson County businessmen saw an opportunity to plan a town in the southwestern corner of Abbeville District. It was named for James Edward Calhoun, a relative of John C. Calhoun and the owner of Millwood, a large estate on the Savannah River.

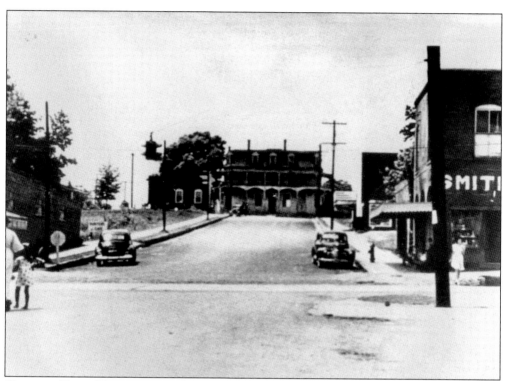

CALHOUN FALLS HOTEL. Pictured is Cox Avenue in Calhoun Falls with the old hotel in the background. The old hotel, originally called Millwood Inn, no longer exists, but Cox Avenue is still the commercial heart of Calhoun Falls. Cox Avenue was named for Judge W.F. Cox, one of the investors of the Western Carolina Land Company, which built the 22-room hotel.

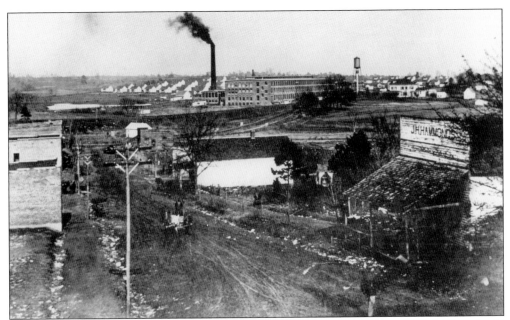

CALHOUN FALLS MILL AND J.H. HAMMOND STORE. By 1915, the Calhoun Falls Mill and mill village were well established. Mr. Ernest M. Lander was general manager of the mill. His father, Dr. Samuel Lander, founded Lander College in Greenwood, South Carolina. The mill village had its own church, band, several schools, and a large mercantile. Items in the store ranged from baby clothes to caskets. The mill paid employees an average of 60¢ a day for 12 hours worked.

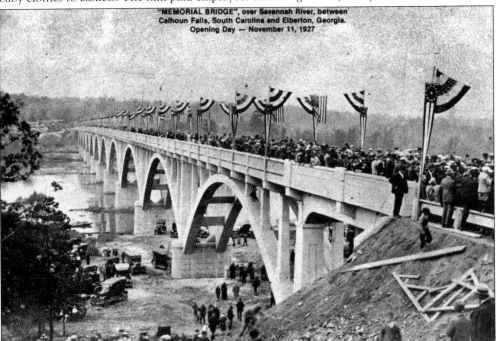

SAVANNAH RIVER MEMORIAL BRIDGE POSTCARD. This postcard shows a view of the dedication of the bridge in 1927. The governor of South Carolina, John Gardiner Richards, attended the dedication, along with numerous other dignitaries.

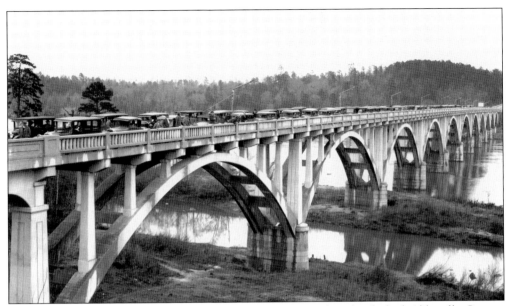

SAVANNAH RIVER BRIDGE. The Georgia-Carolina Memorial Bridge linked Abbeville County with Elbert County, Georgia. It was dedicated at the opening ceremony on November 11, 1927, to the memory of the soldiers killed in World War I. Until then, the Savannah River was crossed by ferry. The bridge is now under water because of the building of Lake Russell and the Richard B. Russell Dam.

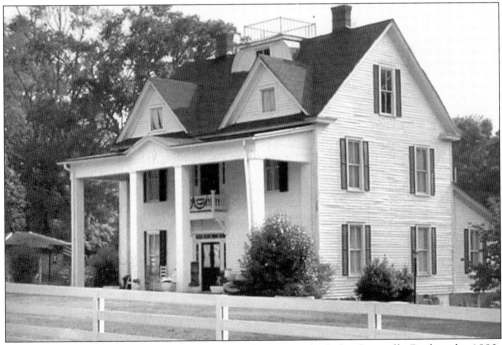

BEAL-SHERARD HOUSE, CALHOUN FALLS. This house was built for Granville Beal in the 1880s on the plantation of James Edward Calhoun. Mr. Beal was the manager of the Calhoun estate, which included 13,000 acres along the Savannah River. Frank Sherard obtained the house in the 1920s.

LAWSON-PETTIGREW HOUSE, CALHOUN FALLS. This home was built in 1865 by a family whose last name was Lawson. Subsequent owners include the Pettigrew family, who still reside in the home.

OLD BANK BUILDING, CALHOUN FALLS. This building dates from the early 1900s. The Anderson Mercantile Bank established branch banks in Calhoun Falls, Iva, Lowndesville, Mt. Carmel, and Willington. The bank failed during the Depression. This building is now owned by John McAllister, who has begun restoration of it.

RURAL ABBEVILLE COUNTY ROAD MAINTENANCE, 1920s. The dirt roads were scraped to keep them flat and free of ruts. Ditches were opened and cleaned to prevent water from standing in the road.

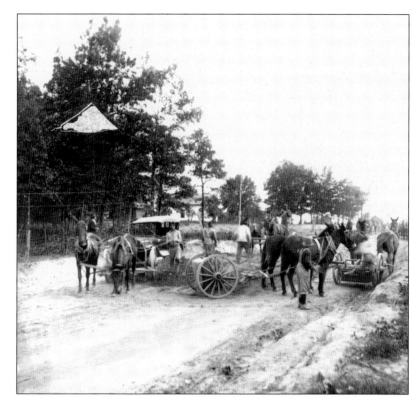

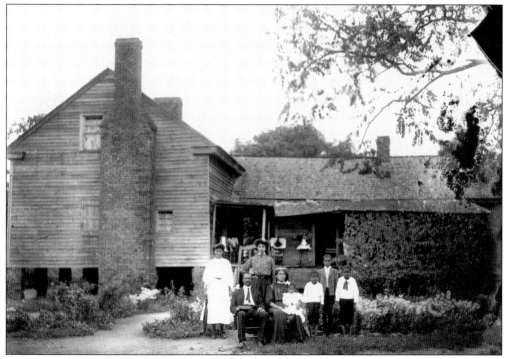

RURAL ABBEVILLE COUNTY HOMESTEAD. This late 1800s picture shows a prosperous African-American family whose names have been lost to time.

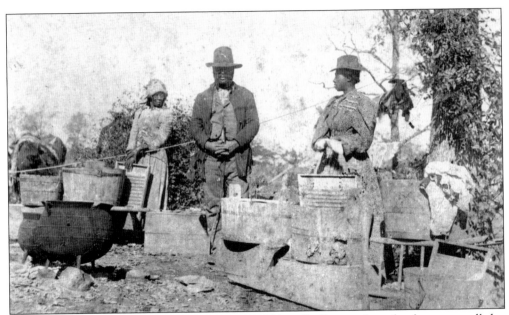

LAUNDRY DAY. This scene shows laundry day in Abbeville County. Laundry day was an all-day process using lye soap. The cleanest clothes were washed first, and that water was used later for the most soiled. It was not unusual for freed African Americans to take in laundry as a source of income.

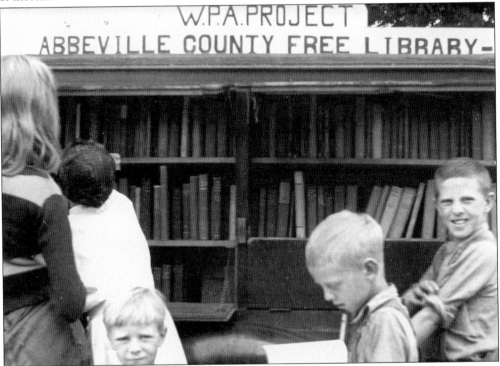

WPA PROJECT. The Works Project Administration was passed during the Great Depression to keep people employed. The Abbeville County Free Library was constructed as a WPA project and is pictured probably in the 1930s.

Six

DONALDS

Donalds was one of four townships laid out west of Ninety-Six as a buffer between white and Cherokee lands. It was originally called Boonsborough Township in 1763, named for Gov. Thomas Boone. Later, the name was changed to honor the Donald (or Donnald) family of Ulster Scots. It later became a busy terminus on the Southern Railway main line and is today a small farming community a few miles from Due West.

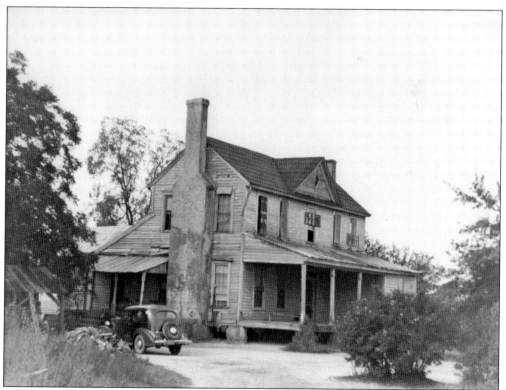

DODSON HOUSE. This house was located in Donalds; the photograph was made around 1932. Many formerly nice homes fell into disrepair during the Great Depression. The Depression, in addition to the boll weevil, made for hard times. Note the tin over the windows.

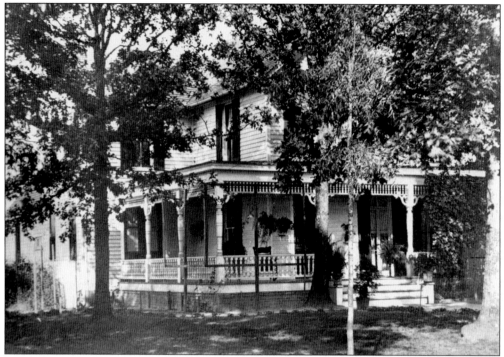

LEONA DONALD HOME. This house was built in 1872 by Samuel Donald for Leona Donald when she married Josh Caldwell. This picture dates from 1911.

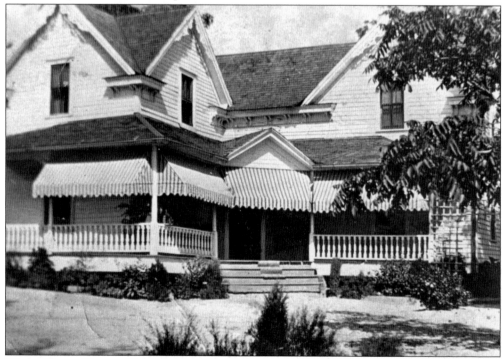

WILEY MURFF HOUSE. This house was located in Donalds. It is a Victorian with commodious porches and sawn bargeboard on the eaves.

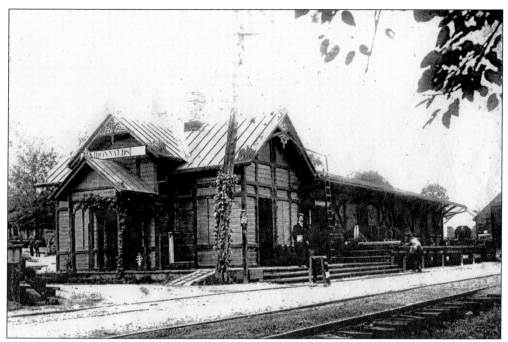

DONALDS TRAIN STATION. This picture was made in 1898 at the Donalds Southern Railway depot. Donalds was on the main Southern Railway line from Greenwood to Anderson and was also the terminus for several small branch lines, such as the Donalds–Due West Railway.

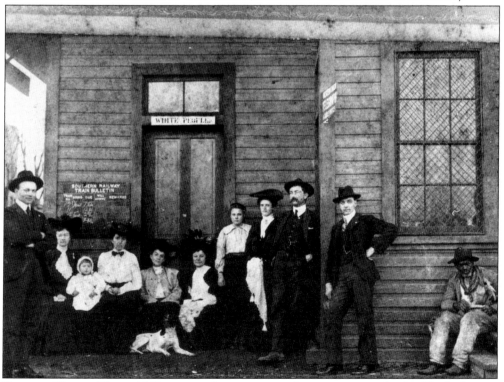

DONALDS DEPOT. This *c.* 1890s picture shows a group of citizens waiting for the "Dinky."

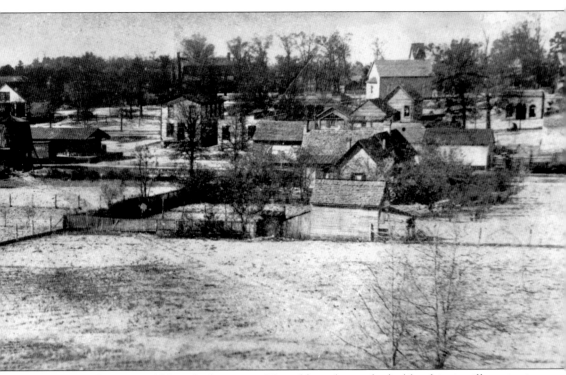

Town of Donalds. Although the town of Donalds no longer looks like this, it still retains its quiet charm and quaint character. The date of this picture is unknown.

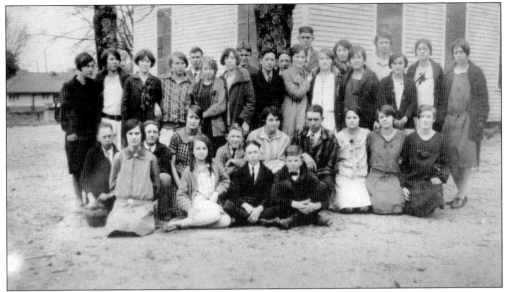

DONALDS HIGH SCHOOL. The classes of 1928, 1929, and 1930 of Donalds High School are shown in this image. The school was later closed when it was combined with Dixie High School in Due West.

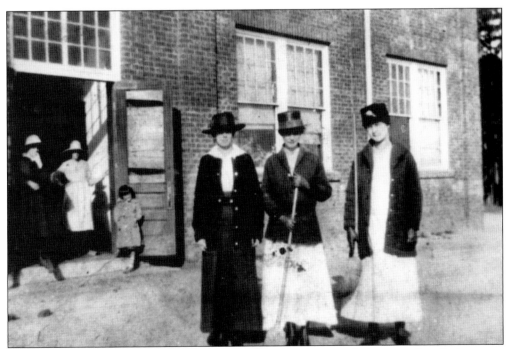

LADIES IN FRONT OF DONALDS SCHOOL. This early 1900s photograph shows unidentified women, possibly teachers, in front of the school.

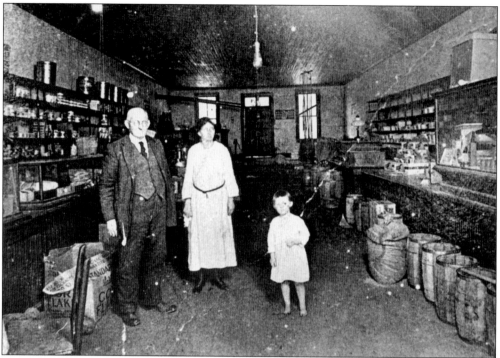

GRAHAM'S STORE. This 1907 interior picture of Graham's Store in Donalds shows Mr. and Mrs. Tommy Graham and a little girl named Mary. The store was at the center of town.

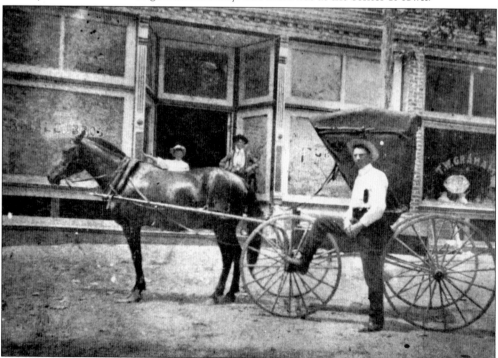

GRAHAM'S STORE. This view shows the front of the Tribble Brothers (left) and T.W. Graham Store (right) in Donalds. Charlie Tribble is standing beside the buggy.

DONALDS UNITED METHODIST CHURCH. A church member secured the title to a lot in 1883 to build this church, originally called Donnalds Methodist Episcopal Church. The second "n" was dropped in 1893. The original bell still hangs in the steeple and the interior still contains the original walnut pulpit furniture and communion table.

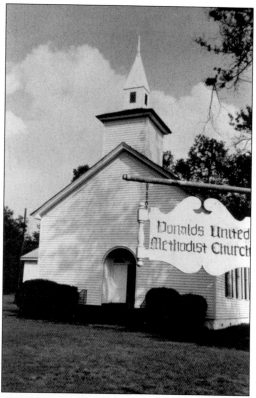

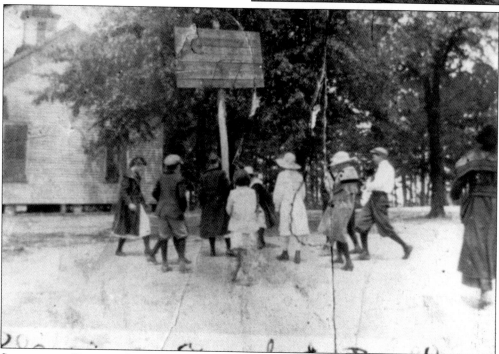

STUDENTS AT DONALDS SCHOOL. The students are playing basketball with the Methodist church in the background. Notice the game includes both boys and girls.

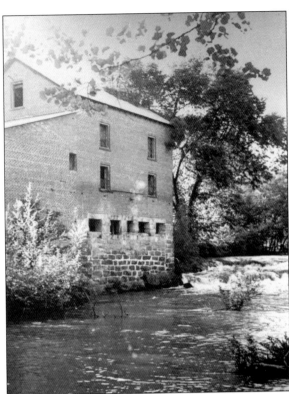

ERWIN'S MILL. This picture was made in July 1907 and shows the gristmill that was located in Donalds.

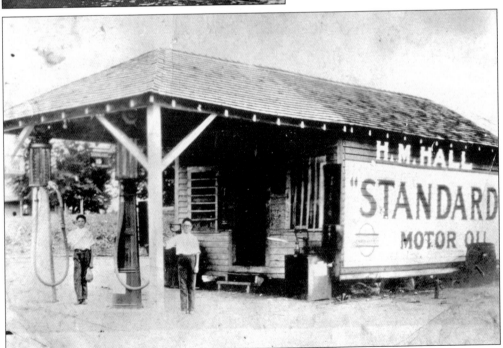

HALL'S STORE. This February 1924 picture shows Hall's Store, which was built in 1920 on Highway 252, one mile from Ware Shoals. The general store sold gas and kerosene as well and was a voting precinct. Fred and Clinton Hall are standing in front of store.

Seven

DUE WEST

Due West took its name from an old Revolutionary War trading post, established by a man named DeWitt or Duett on the Cherokee Path. In the years following the Revolution, the Associate Reformed Presbyterians moved into South Carolina and, in 1790, built a church at Due West Corner. Erskine College was established in 1839 as the first four-year church-affiliated college in South Carolina.

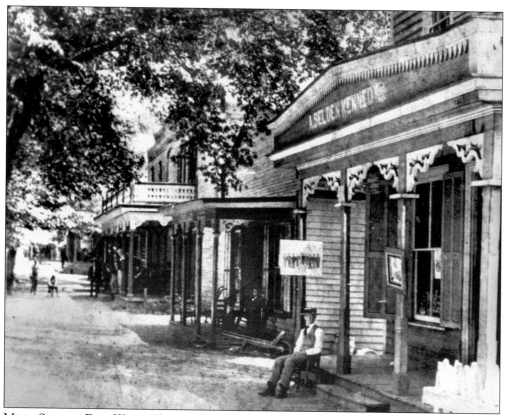

MAIN STREET, DUE WEST. This picture, taken around 1900, shows the old Due West Hotel, which no longer exists, in the center. The building at the forefront is thought to be the business of Sedden Kennedy.

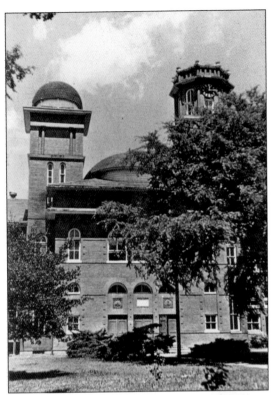

ERSKINE TOWERS, ERSKINE COLLEGE. This three-story brick building was erected in 1893 on the same site as the first college building, which was constructed in 1842. It is notable for its towers, town clock, and a central dome and is still in existence.

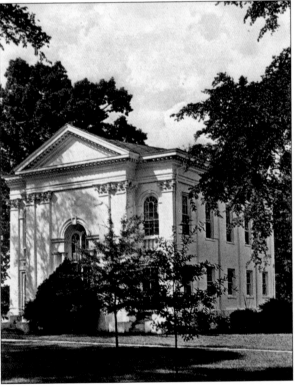

PHILOMATHEUM HALL. This building is the oldest building on the Erskine College campus. It was designed in the Italian Renaissance style by architect Thomas Veal of Columbia. Constructed in 1859 and still in use, it is the home of the Philomatheum Literary Society. The society meeting room on the second floor features an elaborate ceiling mural and trompe l'oeil podium.

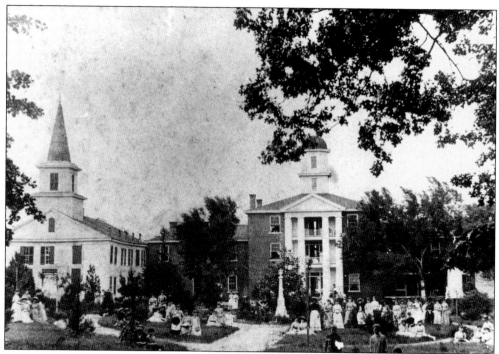

ERSKINE COLLEGE. Bonner Hall can be seen at the center of this photograph, and the church is the old A.R.P. Church, which was moved here to be used as a grammar school and is no longer standing. Bonner Hall burned in the 1960s and has been rebuilt.

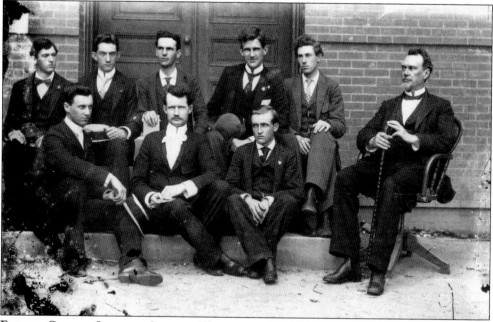

ERSKINE COLLEGE LITERARY SOCIETY. This group of young men were members of the Erskine College Literary Society. There were two literary societies on campus—Philomatheum and Euphemian. The two rival societies had heated debates to help students develop oratory skills.

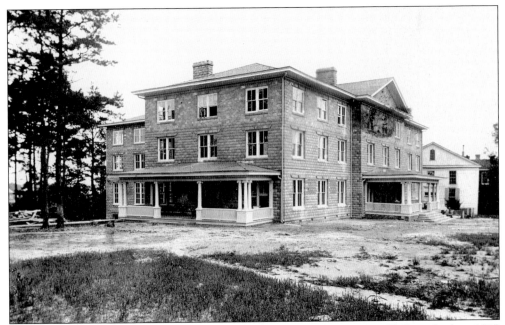

CARNEGIE HALL. A three-story dormitory for freshmen women, Carnegie Hall was built in 1907 and is the oldest dormitory on the Erskine College campus. It was restored and rennovated in 1993.

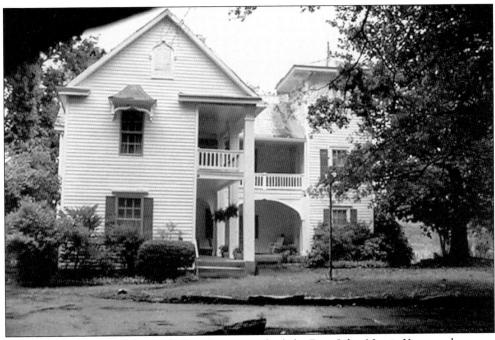

YOUNG HOUSE. This early antebellum house was built by Rev. John Norris Young, who came to South Carolina as a young boy from Ohio. He became an Associate Reformed Presbyterian minister and taught at Erskine College, where he also served as college treasurer. The house is still in the hands of the Young family.

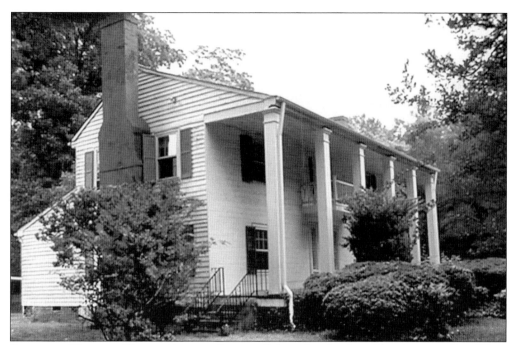

BROWNLEE-KENNEDY HOUSE, CHURCH STREET. Believed to be the oldest house in Due West, this two-story rectangular weatherboard house has a medium gabled roof. The Brownlee family was one of the first two families to settle in what was later the town of Due West.

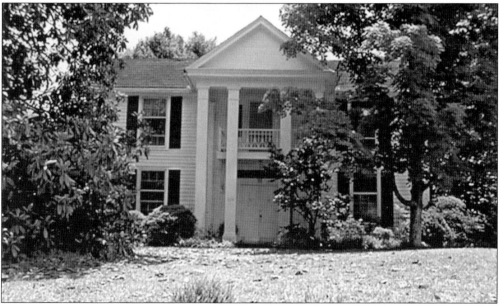

LESESNE HOUSE, WEST MAIN STREET. This two-story weatherboard house with a two-story pedimented portico was built about 1840 by the Sloan family. Like several other Due West homes, the second story was added in the 1870s. The house is sometimes called the "House of Presidents" because it was occupied by Dr. J.M Lesesne, president of Erskine College, Dr. James R. McCain, president of Agnes Scott College, and Dr. J. M. Lesesne Jr., president of Wofford College.

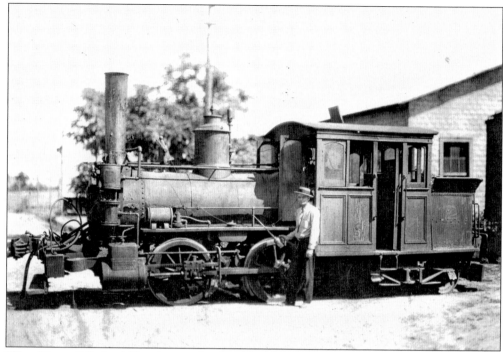

"The Dinky." Roland Hawthorne, the fireman for the Dinky, is pictured here. The line ran from Donalds to Due West. This train ran only four miles between the two towns. The engine was given the pet name of "the Dinky" by the Erskine College boys.

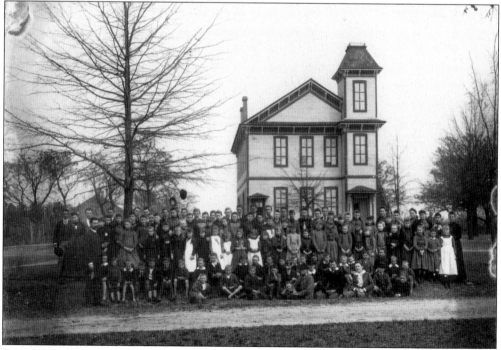

Due West Elementary School. The building pictured here is believed to be Due West Elementary School sometime in the late 1800s. It has since been lost to time.

Eight

LOWNDESVILLE
Town of the Seven Hills

Charted in 1839, Lowndesville was once the largest town in this section of the county and was named at the request of Abbeville native, Langdon Cheves, for U.S. Senator William Lowndes. It was a thriving farm and trade area at the turn of the last century. Today, this quaint village is on the northern shores of Lake Russell.

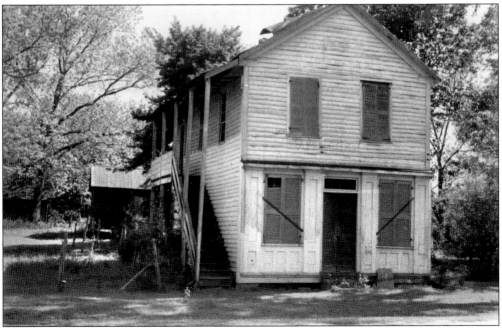

ROSLIN MASONIC LODGE NO. 86, LOWNDESVILLE, ABBEVILLE DISTRICT. The lodge in Lowndesville is one of the oldest in the state outside of Charleston. Its warrant was granted on June 4, 1852, to "John Brownlee, W.M., John C. Speer." This is one of the numerous offspring of Clinton Lodge No. 3 at Abbeville Courthouse. The lodge derives its name from the St. Clairs of Roslin, who were for many generations the hereditary Grand Masters of Scotland.

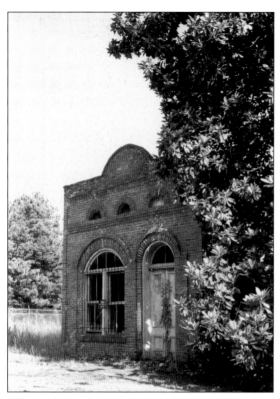

LOWNDESVILLE BANK. This bank was organized December 12, 1890, with the following incorporators: James B. Franks, E.R. Horton, J.O. Chambers, Thomas A. Sherard, Albert J. Clinkscales, Arthur L. Latimer, James M. Latimer, and Theophilus Baker. Later, the building housed a U.S. Post Office.

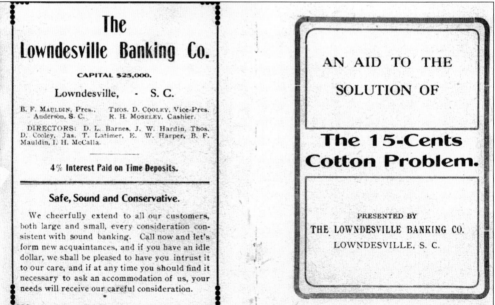

LOWNDESVILLE BANKING COMPANY PAMPHLET: "AN AID TO THE SOLUTION OF THE 15-CENTS COTTON PROBLEM," JANUARY 1908. This document was found in the Baker Building along with numerous other documents relating to the history of Lowndesville. The bank was organized on May 23, 1904, and officers were B.F. Mauldin, president, and Thomas D. Cooley, vice president. R.H. Mosely was the cashier.

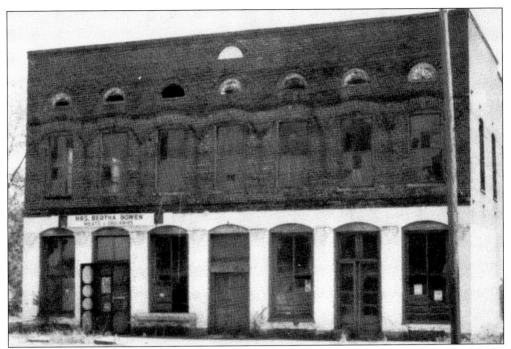

BAKER BUILDING. This building was constructed in 1888 on Main Street in Lowndesville by J.M. Baker. The bottom of the two-story double store was used by merchants, while the upper floor served as an office. Dr. Curtis Fennell had a dental office, and Dr. J.D. Wilson practiced medicine there. The building no longer stands.

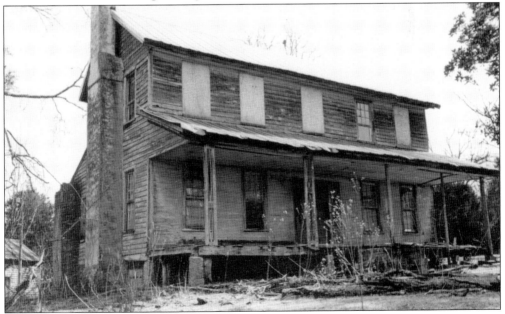

DR. A.J. SPEER HOME, LOWNDESVILLE. This home was built in 1854 by Julius F.C. DuPre, who became a professor of horticulture at Clemson University. Dr. A.J. Speer bought and lived in this house for many years. Others who lived here included Lawrence Speer, Joseph Gilbert, Sam Cann, John Philips, Frank Bonds, Hampton Bonds, and Prue McCarley.

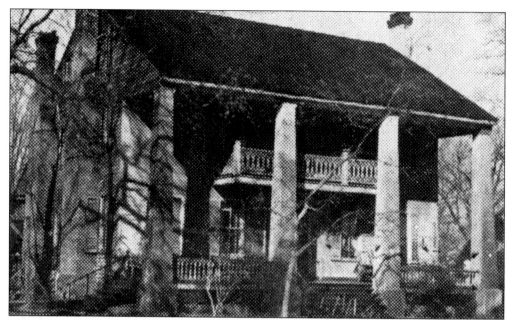

MOSELY HOUSE. Built in 1843, this house was lost to the community when it was torn down in 1968. Dr. Mosely was a dentist, and he and his office resided here. He also served as postmaster for the town of Lowndesville, with his home serving as the temporary post. The last reunion of the Confederate veterans from South Carolina Company I took place at the Mosely home in 1896.

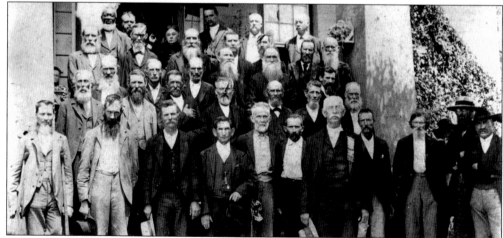

CONFEDERATE SURVIVOR'S REUNION. A reunion of Company I, 14th Infantry Regiment, South Carolina Volunteers, C.S.A., was held in Lowndesville on September 2, 1896. From left to right are (first row) Marshall Hill, William Campbell, James Blanchett, Charles Loafer, Whit McCurry, Obe Cann, Capt. W.R. White, Albert Baker, Sam Hall, and three unidentified men in hats who are possible veterans from another company; (second row) Hut Loftis, Mat Barnes, Arch Mauldin, Joe Bowen, Press B. Suber, Stewart Cann, and Martin Campbell; (third row) Jacob Alewine, Gus Sutherland, George Morrow, Tom Stucky, unidentified, and William D. Mann; (fourth row) Thomas A. Cater, Lt. M.T. Hutchinson, Bowman Patterson, Sam Christopher, Dr. J.B. Mosely, J.J. Hardy, and Jim Hampton; (fifth row) John McCoppin (cook), I.H. McCalla, Mrs. W.R. White (who presented the unit's colors in 1861), E.W. Harper, Gen. T.A. Carwile (speaker of the day), and Sgt. J.E. Brownlee. (Courtesy of the late Herman A. Carlisle.)

PRESBYTERIAN CHURCH, LOWNDESVILLE.
As early as 1826, there was a Presbyterian congregation in or near the town site. Named Providence, it united on May 1842 with New Harmony Presbyterian Church. The combined churches also adopted the name of Providence. Providence Presbyterian Church is located in a grove of oak trees on the west side of Main Street.

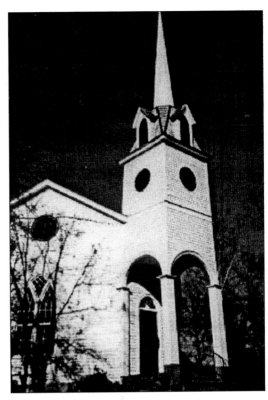

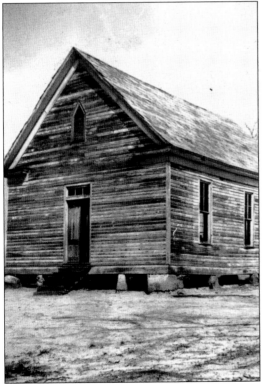

RIDGE CHURCH. The construction of this church began with the deeding of land by Mr. E.W. Harper of Lowndesville on September 13, 1884. The structure was completed and officially dedicated on November 9, 1890. The members donated lumber and labor, and candles were used for light. The Masonic Lodge of Lowndesville purchased shutters for the windows, and a belfry was later added with a bell donated by the C&WC Railroad.

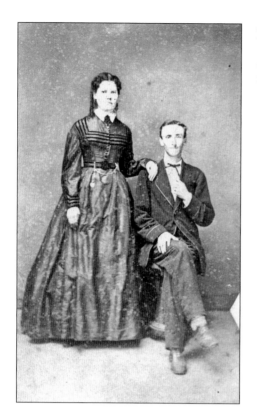

MR. AND MRS. DOWER KENNEDY. Elizabeth Betty Baker married Lorenzo Dow Kennedy on September 21, 1886. They were natives and residents of Lowndesville.

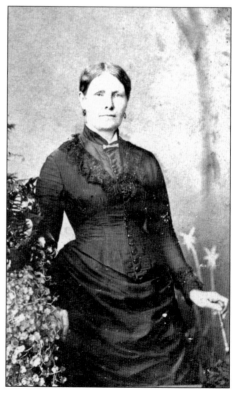

BETTY BAKER KENNEDY. This Lowndesville resident was a daughter of Joseph Baker and Laney Griffin Baker. She married Lorenzo Dow Kennedy and then J.L. Richardson. After the "War of Northern Aggression," it is said that she "papered a room with her Confederate money" as a reminder of better times!

David Kennon Cooley. A merchant in Lowndesville, David Kennon Cooley owned Cooley & Allen General Merchandise, located near the depot in Lowndesville. Mr. Cooley's home was one of seven residences lost during the great Lowndesville fire on February, 14, 1919.

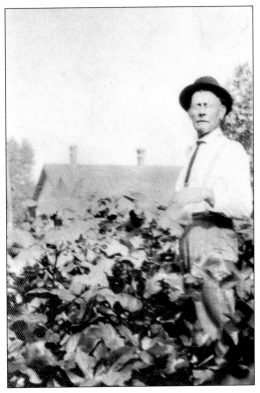

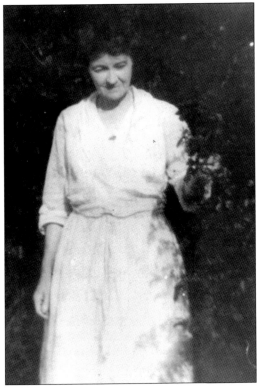

Margaret Cooley. Margaret Lucinda Floyd Cooley, wife of David Kennon Cooley, was a resident of Lowndesville. She is pictured here c. 1920s.

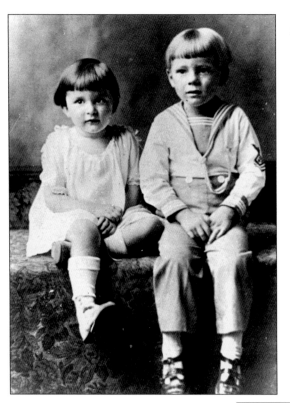

ANNE ROGERS AND WILEY FRANK HARVEY JR. This 1928 photograph shows two young Lowndesville residents, Anne Rogers and Wiley Frank Harvey Jr.

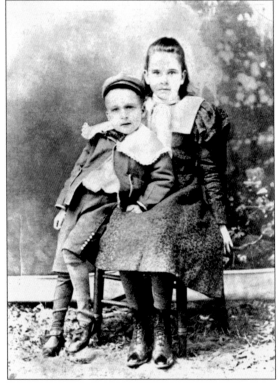

HARVEY CHILDREN. Wiley F. Harvey Sr. and his sister, Annie Harvey, are shown in a picture made in Halifax, North Carolina, in the 1890s. Mr. Harvey, a World War I veteran and attorney, retired with his family to Lowndesville in the 1930s and lived there for the remainder of his life.

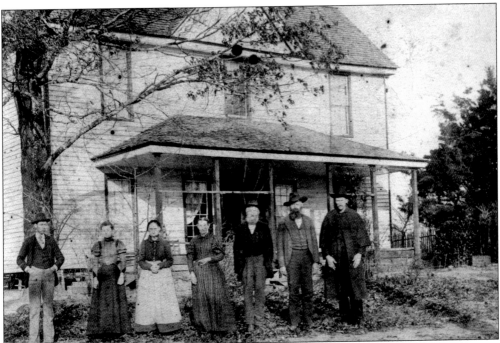

THE KAY HOME, LOWNDESVILLE. This photo was taken around 1899 at the Kay home. Among those pictured are Samuel Jay McCullough, Mary (Molly) McCullough, Catherine White (Mrs. S.T. McCullough), Eliza Beaty White (Mrs. Ezekiel), and Samuel (Sam) Thomson McCullough. The visitors are unidentified.

THE FRANKS HOME. This large plantation home was east of Lowndesville on Highway 71. Built from 1850 to 1860 by William C. Cozby, the home had two interior staircases and was known as the "Franks Place." The outer two of the four columns fell during the 1886 earthquake that hit Charleston and moved to the Upcountry. Aftershocks continued to be felt for almost a month. Regrettably, this house burned May 2, 1987, probably as result of vandalism. The remaining columns can still be seen. (Courtesy of George Morrow.)

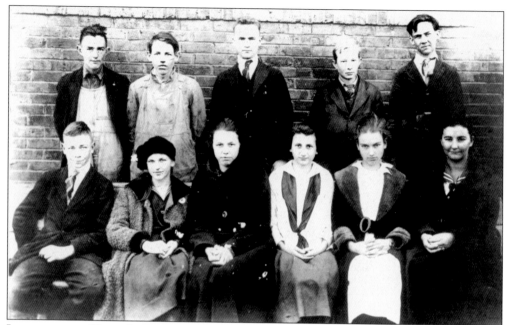

LOWNDESVILLE HIGH SCHOOL CLASS. Pictured from left to right are (front row) Wallace Cooley, Pauline Ballenger, Zelpha Hardin, Olivia Drennan, Allie Mae Parnell, and Bessie Ficquette; (back row) George Ficquette, Trude Benson, L.C. Griffin (teacher), Floyd Cooley, and Harold Carlisle.

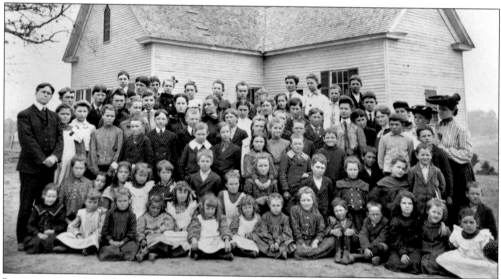

LOWNDESVILLE PUBLIC SCHOOL. This photograph dates from around 1905–1907. The school was built around 1891. Emma B. Carlisle offered names as follows, from left to right, in 1987: (first row) Fannie Ficquette, others unidentified; (second row) unidentified, Ruby Ficquette Riser, Virginia Latimer, George Harper, ten unidentified, and Blanche Cooley; (third row) four unidentified, Mary Hardin Pruitt, Lucia Parnell Hilley, Ruth Bowman Mullin, Fred Ficquette, Louise Bell Clinkscales, and Una Baskin; (fourth row) ten unidentified, Birdie Bell Johnson, two unidentified, Minnie Fennell Ligon, unidentified, and Wendell Latimer; (fifth row) ten unidentified, Ben Bonds, unidentified, and Willie L. Bowman.

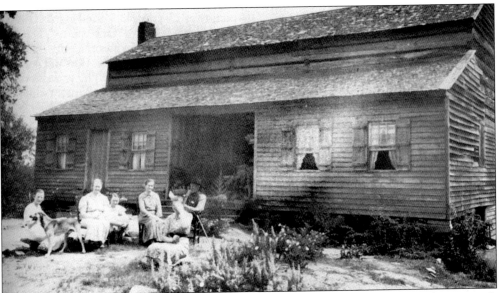

CALDWELL-HUTCHINSON FARM. This front view of house shows the center dogtrot with Hutchinson family members in front of the house. The upper story was made of massive 49-foot-long pine timber logs, which were hand hewn and squared.

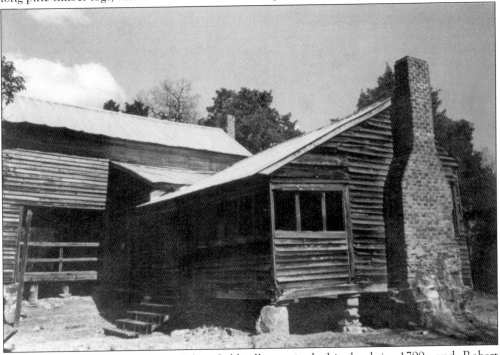

CALDWELL-HUTCHINSON FARM. John Caldwell acquired this land in 1799, and Robert Hutchinson acquired the land in 1876. Hutchinson's great-grandchildren, Bandon and Catherine Hutchinson (brother and sister), were the last residents of the house. They lived there until 1990 when the property became part of the buffer zone for Russell Lake. The house began as one room of hewn logs, and as the family grew, rooms were added over the next 100 years. The house is now part of the McCalla State Natural Area.

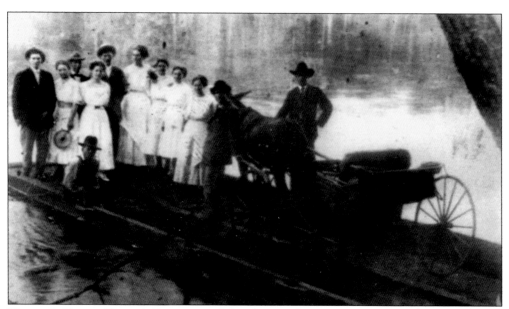

HARPER'S FERRY. Harper's Ferry crossed the Savannah River at Lowndesville. On April 4, 1920, a cable on the Georgia side of the river broke and 10 young people perished. The bodies that were recovered are buried under a single headstone at Providence Presbyterian Church in Lowndesville.

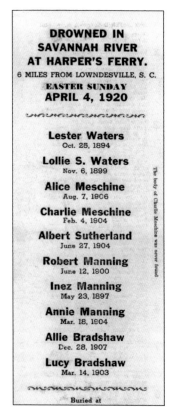

DROWNED IN
SAVANNAH RIVER
AT HARPER'S FERRY.
6 MILES FROM LOWNDESVILLE, S. C.
EASTER SUNDAY
APRIL 4, 1920

Lester Waters
Oct. 25, 1894

Lollie S. Waters
Nov. 6, 1899

Alice Meschine
Aug. 7, 1906

Charlie Meschine
Feb. 4, 1904

Albert Sutherland
June 27, 1904

Robert Manning
June 12, 1900

Inez Manning
May 23, 1897

Annie Manning
Mar. 18, 1904

Allie Bradshaw
Dec. 28, 1907

Lucy Bradshaw
Mar. 14, 1903

The body of Charlie Meschine was never found

Buried at

CARD MEMORIAL TO HARPER'S FERRY TRAGEDY. This memorial card recalled the April 4, 1920 tragedy when 10 young people drowned in the rain-swollen Savannah River. The ferry capsized, and only one person survived.

Nine

COMMUNITIES WITHIN ABBEVILLE COUNTY

The following communities are important sections of Abbeville County. Cedar Springs was once in Abbeville District, but only the Frazier House now remains in the county. Monterey was named to honor the South Carolina Palmetto Regiment's actions during Mexico. Legend has it that The Nation area was named after the Cherokee Nation. The Edgewood section of the county is the home of the Lemuel Reid Plantation and the Edgewood school. Antreville is a farming community that borders The Nation. Rogers' Crossroad is located between the Monterey Community and The Nation and has been the seat of the Clinkscales-Rogers family for many generations.

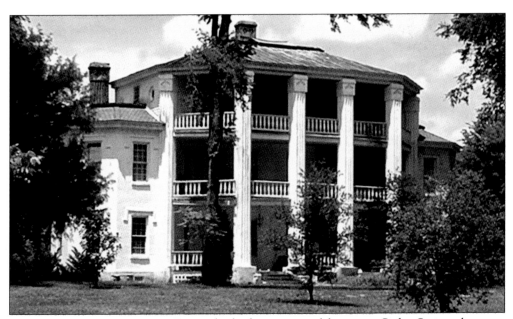

FRAZIER HOUSE. Capt. James Frazier built this octagonal house in Cedar Springs between 1852 and 1856. The house is planned around three octagonal brick towers connected with porches and hallways. The first floor's main room has Gothic mantels and cupboards. The halls feature a double staircase where two family ladies had a double wedding and entered from separate stairs.

SPEER PLANTATION. The original house appears to date to the 1780s. William Speer Sr. had received about 1,400 acres from the State of South Carolina for his service under General Pickens during the American Revolution. The house was located on Carter Island on the Savannah River and relocated to its present site.

MONTEREY. Named after Monterey, Mexico, this house was originally built in 1869. The home was built by George Washington Speer and is still owned and occupied by the Speer family.

GEORGE WASHINGTON SPEER. Pictured in his Confederate uniform in 1861 in Charleston, South Carolina, Speer served in Companies B and G, McGowan's Company, 1st Regiment (Orr's Rifles), Kershaw's Brigade, and South Carolina Infantry. McGowan's Company, which became a highly celebrated unit and took part of the major battles in Virginia and Gettysburg, later became known as McGowan's Brigade. On July 12, 1899, George Speer was only one of five surviving soldiers of Orr's Rifles who attended the funeral of Col. George McDuffie Miller, the commanding officer of Company G and one of Abbeville's Confederate colonels.

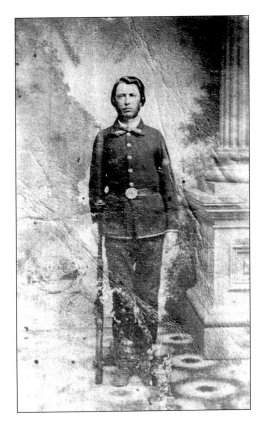

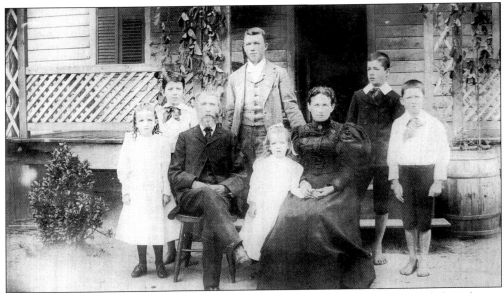

SPEER FAMILY. The George Washington Speer family is pictured in front of their home, Monterey. From left to right are Lila Templeton, William Andrew, G.W., George Mason, Mary Sue, Mary Sue Giles Speer, Arthur Jackson, and Thomas Cater. Direct descendants of Arthur Jackson are the fifth-generation Speers living in the home today.

MONTEREY POST OFFICE. The Monterey Post Office was built in 1847 and torn down in the 1950s. It operated during the Civil War under the Confederate States Postal System.

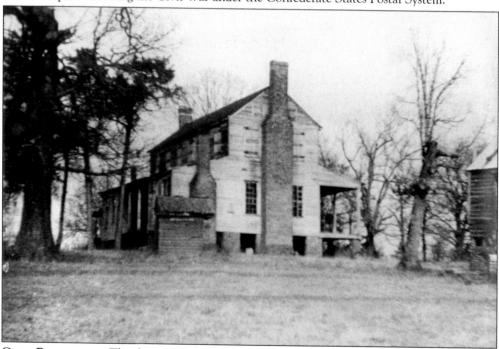

GILES PLANTATION. This house was built in 1812 by Squire William Andrew Giles. He was educated at Waddell Academy near Willington in McCormick County. The house was restored by Mr. and Mrs. Charles Grantham and later by Dr. and Mrs. Mike Fry. (Courtesy of Dr. Mike Fry.)

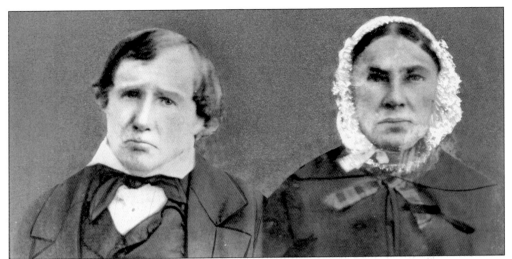

FRANCIS B. CLINKSCALES AND SECOND WIFE, BARBARA PURCELLE HICKMAN CLINKSCALES. This union resulted in the birth of Francis's last and tenth child, William Virgil Clinkscales. The photograph was made in June 1857, one or two days after the death of daughter Mary Caroline, which explains the sad expression on the father's face. He died the following year. Clinkscales was a planter whose other holdings included railroad investments. His plantation covered thousands of acres at the northernmost forks of Penney Creek, as seen on the 1820 Abbeville District Map, surveyed by William Robertson and improved for the Mills Atlas in 1824. That home burned in the 1930s.

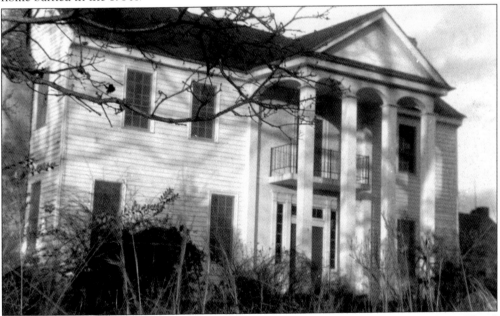

CSA 1ST LT. WILLIAM VIRGIL PURCELLE CLINKSCALES'S PLANTATION. Known as "Home Place" in rural Abbeville on what is now Rogers Road, the plantation later belonged to his daughter Onie Clinkscales Rogers and her son, James. The house is thought to have been built c. 1818 by either a Mr. Boggs or Botts. It was noted for its handsomely carved mantles, "standing proud" paneled wainscoting, and commodious interior stairway, all of which were grained. The house was lost because of abandonment in the late 1990s.

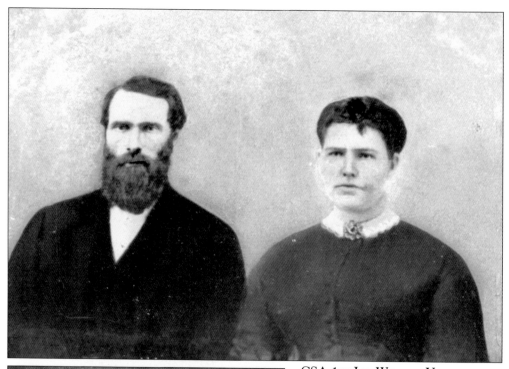

CSA 1st Lt. William Virgil Purcelle Clinkscales and Wife, Lucretia Anne Clinkscales. William was the last child born to Francis B. Clinkscales and educated at Erskine College. A planter and owner of Home Place Plantation and its adjoining Mount Hut farm, he was also a dry goods merchant and owner of a store in Lowndesville that sold sewing machines. When his hired Mexican substitute was killed in the Civil War, he joined the 19th Infantry Company G as a first lieutenant and fought in both Atlanta and Appomattox. He was among those who surrendered with Gen. Robert E. Lee.

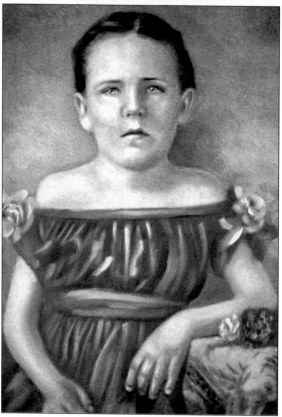

Onie Clinkscales. This portrait shows Miss Onie Clinkscales (Rogers), daughter of 1st Lt. William Virgil Clinkscales and Lucretia Baker Clinkscales, c. 1866. Onie was about six years old in this portrait and was dressed for an "infare" at her parents plantation, per family legend.

Roy Power and William Clinkscales Rogers. These Abbeville natives and friends since youth may have been visiting Atlanta when this photo was taken, since it is stamped "Atlanta." Power was the brother of Abbeville physicians Drs. Eugene and Rayford Power and became a furniture store owner in Abbeville. Will Rogers moved to Winston-Salem, North Carolina, and became plant engineer of the Zinzendorf Hotel.

Pony Riders. Mac Seal and Mary Agnes Bradberry (Caulder) are photographed riding ponies on John Frank Rogers's farm in Abbeville County. Seal was the father of Debbie Seal Hite.

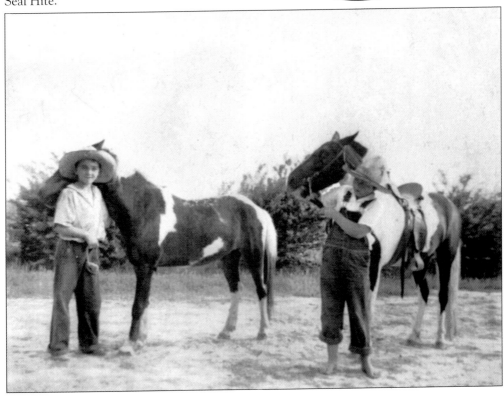

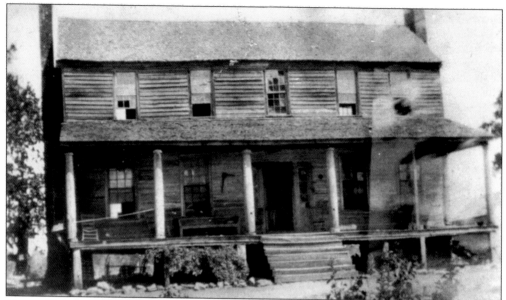

MILLER PLANTATION. The Miller-Benson-Price House, the ancestral home of Mary Stark Davis, was located on Highway 71 near the Bartram historical marker. The house no longer stands, and a number of the furnishings are now owned by the Abbeville County Historical Society. Dr. D. Sloan Benson, who married Mary Elizabeth Miller, lived here during the Civil War. The society has his trunk used in the Civil War, as well as the chairs and divan pictured on the porch. American botanist William Bartram, son of renowned botanist John Bartram, visited trader Alexander Cameron in 1775 at Lough-Abber, which adjoined this property.

MILLER SKETCH. Slave cabins located across the road from the Miller-Benson-Price house are depicted in this c. 1854 drawing by Mary Elizabeth Miller (Benson), wife of Dr. Nicholas Benson. Mary studied art as a student in Charleston. The cabins were located on a piece of property that stretched to Penney's Creek known as "Mutton Leg." Adjoining parcels of land on the same plantation were called "Sheep Walk" and "Zig Zag."

BROWNLEE SCHOOL. Named for the Brownlee family who had a plantation approximately one mile above the school, this one-room school was located in rural Abbeville County. The structure, which sat on a knoll, was demolished c. 1959. At that time, it still had its old iron and wooden Victorian desks with ink bottle holders. Among its early teachers were a Miss Brownlee, Miss Nora Jenkins (Bradberry) from 1914 to 1915, Miss Ella Mae Nance, Miss Hattye Rogers (Bradberry), and Miss Mary Lou Rogers (Meyers). The students were required to gather their own wood for the potbelly stove.

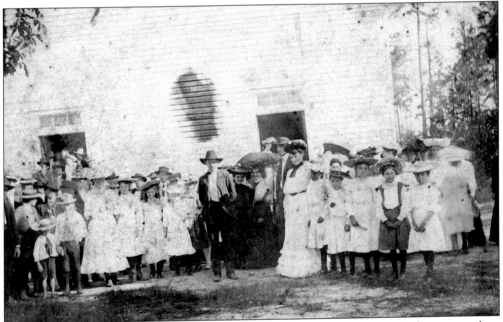

MIDWAY BAPTIST CHURCH. This picture, which dates from about 1903–1906, depicts members of Midway Baptist Church in The Nation community. Wilhelmina Hodge (Rogers) is the child standing beside Rose McClellan, the tall woman in white dress with a black hat. Wilhelmina's brother, Adger Hodge, is on the left of Mrs. McClellan. The tall man on the right side of the left door is Wilhelmina and Adger's father, George Thomas Hodge. George's father, Alexander Hodge, gave the land for Midway Baptist Church, which had been part of a land grant to Thomas Hodge from King George III in the late 1700s.

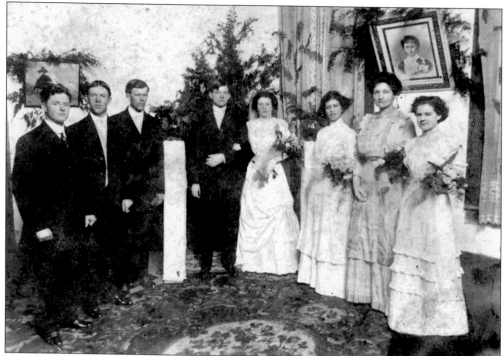

McCain-King Wedding. This *c.* 1908 picture was made in the bride's family home in Abbeville County. The bride is Emma King and the groom is Dacus McCain. From left to right are unknown groomsman, Charlie King (brother of the bride), unknown groomsman, groom, bride, Etta King (sister of the bride), Rose McClellan, and Wilhelmina Hodge (Rogers).

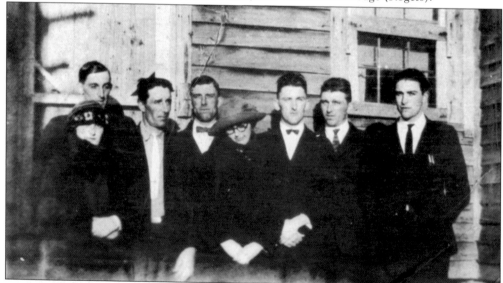

The Grant Family. Shown here from left to right, Rupert Carl Grant, Martha Lorena Grant, Faris Adams Grant, George Gassoway Grant, Hamatal Louellen Grant, David Pinckney Grant, James Lafoy Grant, and Robert Alton Grant are ancestors of Sarah Ruth Grant Harris (not shown) of Abbeville. The picture is from the early 1920s. They lived in The Nation area of Abbeville County. (Courtesy of Ruth G. Harris.)

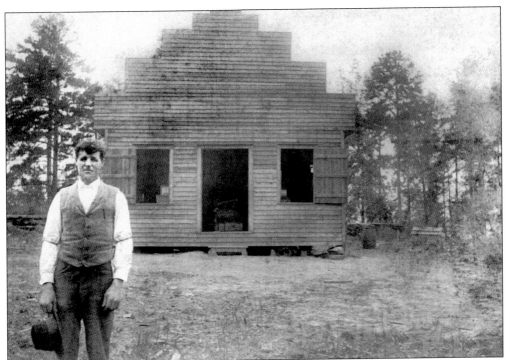

CRAWFORD STORE. About 1898, Will Crawford stands in front of the store he owned with his brother Bob. It was located across from Martin River Mill in the Antreville area of Abbeville.

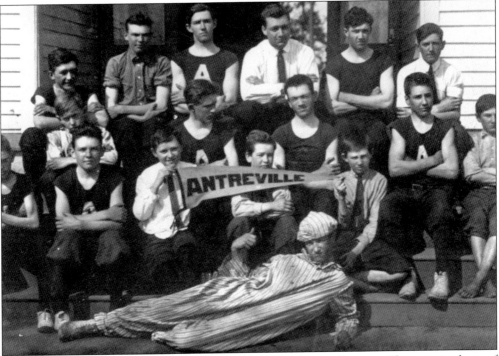

ANTREVILLE. This group of young men are from the Antreville area. They are in front of Antreville High School, built after the 1925 fire destroyed the previous two-story building.

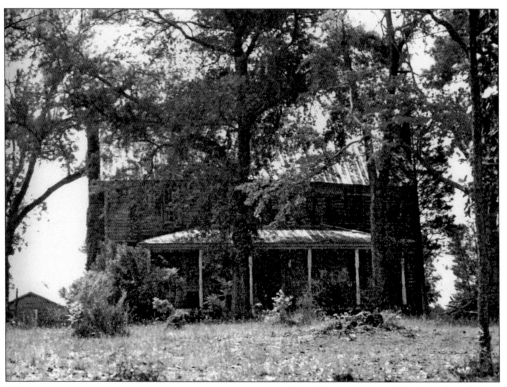

REID PLACE. Lemuel Reid replaced his old home on the Reid plantation with this updated house in 1861. Parts of this plantation were purchased in 1775 by Lemuel Reid's grandfather, Hugh Reid. It was located in the Edgewood area of Abbeville, four miles from town on the Anderson Highway. (Courtesy of Marilyn Reid.)

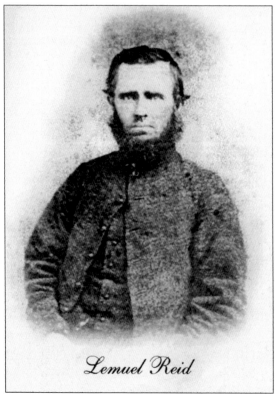

Lemuel Reid

LEMUEL REID. This photograph shows Abbeville planter Lemuel Reid. Documentation of daily life at his plantation, frequent travels around Abbeville County and to Williamston, and the dinners he attended are recorded in his 1861, 1862, and 1864 diaries. These also included recollections of events of the Civil War.